IMAGES
of Rail

CHICAGO TROLLEYS

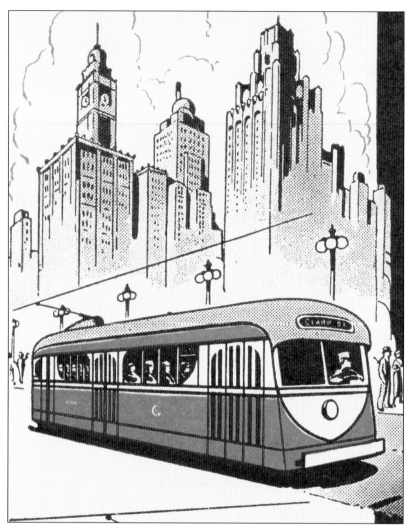

This illustration shows experimental streamlined streetcar 7001 as featured in a 1935 Chicago Surface Lines (CSL) brochure. This car, developed by CSL and built by the J.G. Brill Company, was a predecessor of the iconic Presidents' Conference Committee (PCC) streetcar that appeared in 1936. (Author's collection.)

ON THE COVER: Car 1747 was built between 1885 and 1893 by the Chicago City Railway, which operated lines on the South Side starting in April 1859. This is a single-truck (one set of wheels) open electric car. It is most likely a cable car retrofitted with a trolley and traction motor. The man at right is conductor William Stevely Atchison (1861–1921), and this image came from his granddaughter. (Courtesy of Debbie Becker.)

IMAGES
of Rail

CHICAGO TROLLEYS

David Sadowski

ARCADIA
PUBLISHING

Published by Arcadia Publishing
Charleston, South Carolina

Printed in the United States of America

Library of Congress Control Number: 2017933090

For all general information, please contact Arcadia Publishing:
Telephone 843-853-2070
Fax 843-853-0044
E-mail sales@arcadiapublishing.com
For customer service and orders:
Toll-Free 1-888-313-2665

Visit us on the Internet at www.arcadiapublishing.com

*Dedicated to the memory of Bradley Scott Criss (1963–2016), who
pursued excellence in everything he did and often achieved it*

CONTENTS

ACKNOWLEDGMENTS

The author wishes to thank the following individuals, without whose assistance this book would not have been possible: Debbie Becker, John F. Bromley, Anne Edvenson, Clark Frazier, Diana L. Koester, the late Malcolm D. McCarter, Art Peterson, Mike Raia, Don Ross, the late Charles L. Tauscher, George Trapp, Jeffrey L. Wien, and Chuck Wlodarczyk. Special thanks go to Arcadia Publishing editor Liz Gurley, who helped make this a much better book.

The author consulted the following publications while researching this book:

Brown, John J., Charles A. Brown, James E. Coleman, and Robert E. Johnson. *Complete Roster of Equipment of the Chicago Surface Lines.* Chicago: Central Electric Railfans' Association Bulletin 27, 1941.

Buckley, James J. *The Evanston Railway Company.* Chicago: Electric Railway Historical Society Bulletin 28, 1958.

Hilton, George W. *Cable Railways of Chicago.* Chicago: Electric Railway Historical Society Bulletin 10, 1954.

Lind, Alan R. *Chicago Surface Lines, an Illustrated History.* Third edition. Park Forest, IL: Transport History Press, 1979.

Mason, John R. and Raymond A. Fleming. *Street Car R.P.O. Service in Chicago.* Chicago: Mobile Post Office Society, 1983.

"Mass Transportation in Chicago Moves Forward." *Mass Transportation.* January 1939: 4–10.

For further reading, check out the author's transit blog at www.thetrolleydodger.com. Unless otherwise noted, all images appear courtesy of the author.

INTRODUCTION

Chicago incorporated as a city in 1837 and experienced rapid growth. The first steam railroad was built in 1848, and many others followed. By 1859, the city had 100,000 residents.

Roads were generally dirt or mud. People needed better ways to get around.

Enterprising businessmen brought an idea to Chicago that already proved successful in the East. Tracks could be laid in city streets, and horses could haul small railcars on fixed routes at reasonable fares.

Thus, on April 25, 1859, the era of horse-powered public transit began in Chicago. Soon, there were regular routes all over. The first two operators were the Chicago City Railway and the North Chicago Street Railroad. Where lines went, growth followed.

These were private companies, but city government was always involved, granting franchises and negotiating terms. There were often squabbles between competing firms.

Horsecars were expensive to operate. For one thing, horses could only work part of the day but ate food day and night. There was a terrible excrement problem.

In 1872, horse populations in major cities were decimated by an equine influenza epidemic, nicknamed "the Great Epizootic." Transit companies sought a better way.

In August 1873, an answer emerged in hilly San Francisco with the opening of the world's first successful cable car line. Unpowered cars used a grip to gain hold of a continuously running cable (powered by a large, centrally located, steam-powered motor) via a trough between the running rails. Cable cars became synonymous with San Francisco and continue to run there today.

Chicago's cable cars began running in 1882. The challenge here was not climbing steep hills, as Chicago is largely flat, but the cold and snowy winters. They succeeded, and Chicago soon had a larger system than San Francisco, with 41 miles of double-tracked routes at its early-1890s peak.

Cable cars never completely replaced horsecars in Chicago, but they formed the backbone of the transit system and carried large numbers of people. Still, they were expensive to build.

Another breakthrough came in 1888, when inventor Frank J. Sprague opened the first streetcar system in Richmond, Virginia, powered by electricity carried through trolley wires. It was an immediate success, and for the next half-century, streetcars dominated public transit.

The first electric Chicago streetcar ran on June 6, 1893. By 1906, streetcars replaced all the city's remaining horsecar and cable car lines. A series of mergers and consolidations followed.

This culminated with the creation of the Chicago Surface Lines (CSL), an association that became the public face of the four remaining streetcar operators on February 1, 1914.

Chicago's elevated ("L") system developed in the 1890s and, to some extent, competed with streetcars. It, too, was privately owned.

In the late 1890s, Frank J. Sprague helped electrify the "L" (originally powered by steam), and pioneered the use of multiple-unit control of rapid transit cars. Most of the system was powered by electrified third rail, but there were portions with overhead wire, mainly at ground level in outlying areas. A 1939 Chicago Surface Lines brochure proclaimed:

> CHICAGO'S STREET RAILWAY SYSTEM is the greatest single factor in the growth and development of the city—and you can check that with the experts!
>
> Many things have happened in the 80 years that have passed since the first horse car line brought the benefits of public transportation to the modest city that was Chicago.
>
> In the romance of surface transportation there is the history of today's great city. The first car line was the forerunner of State Street's famed shopping district of today. The city had growing pains and the transportation lines were extended, improved, and extended again and again. These extensions made possible the growth of all the important business and residential districts that now dot the city. Wherever the extensions were built there were big increases in property values.

The CSL streetcar system reached its zenith in the 1930s. By then, there were also suburban and interurban systems that connected downtown Chicago with Aurora, Elgin, Milwaukee, and South Bend. Two of the three major Chicago interurbans got their access to the Loop via the "L".

The Surface Lines was Chicago's dominant transit provider, carrying more than 75 percent of all local riders. Liberal transfer policies made it possible to reach anywhere in the city on a single fare. A large percentage of the population lived within a half-mile of a streetcar line.

As streets were paved, gas-powered buses arrived during the 1920s. In 1930, these were joined by CSL trolley buses (electric buses with rubber tires and two overhead wires) on Chicago's developing northwest side. (The second overhead wire was used as a ground, while streetcars used the tracks for current return.)

In 1929, the presidents of several street railway companies in the United States collaborated to develop a modern streetcar. Chicago was very much involved, and three different experimental cars were tested here starting in 1934. The result in 1936 was the streamlined "PCC" (Presidents' Conference Committee) streetcar, which quickly became the industry standard.

Chicago ordered 83 "super PCCs" in 1936. These were longer than usual, had an extra set of doors, and were designed for two-man operation. These fast, quiet "Streamliners" were an immediate sensation but still ran into crippling Loop traffic congestion.

By 1937, Boston, Philadelphia, and Newark had built streetcar subways in their downtown areas to segregate trolley traffic. Chicago proposed digging two east-west streetcar subways, in addition to a long-sought rapid transit subway under State Street, and applied for federal funding from the Public Works Administration (PWA).

PWA head Harold L. Ickes rejected streetcar subways and instead approved a west-northwest rapid transit subway. In retrospect, this decision probably led to the eventual phasing out of Chicago's streetcars and their replacement by buses.

New equipment purchases were put on hold "for the duration" during World War II. With gas and tires rationed, trolleys helped the home front win the war.

City fathers had long wanted to unify the surface and rapid transit systems. Efforts to use private ownership failed, and in 1945, the Illinois Legislature and Chicago-area voters approved the creation of the public Chicago Transit Authority (CTA).

A two-year transition, with de facto joint CSL-CTA operation of the surface system, ended on October 1, 1947, when CTA took over operations. During this time, 600 more modern "Green Hornet" PCC streetcars (named after the popular radio program) were ordered.

Soon after, the CTA decided it did not want to operate streetcars, and these were rapidly phased out, the last car operating on June 21, 1958.

CTA ordered 300 more trolley buses in 1951, but in the name of standardization, CTA's trolley buses were also gradually eliminated, and the last one ran in regular service on March 24, 1973.

The CTA continued to use overhead wire on parts of the "L" until September 10, 2004.

Two of the three major interurbans are long gone, but the South Shore Line still runs under electric wire, as does the suburban Metra Electric service (the former Illinois Central Electric).

Electric transit is enjoying a remarkable renaissance in North America and continues to move millions here. Come along for the ride as we tell the story of Chicago's trolleys and the growth of a world-class city, with its hard-working, diverse people.

One

EARLY TRACTION

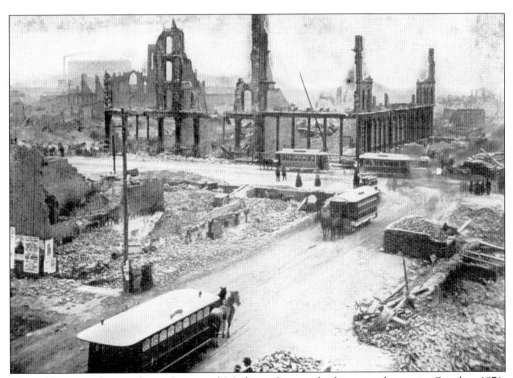

This old postcard view shows State and Madison Streets, looking northeast, in October 1871, shortly after the Great Chicago Fire. The various horsecars shown served the Madison Street, Blue Island Avenue, and State Street lines. Horsecar service, the predecessor of today's public transit, started in April 1859 and quickly became an indispensable part of city life.

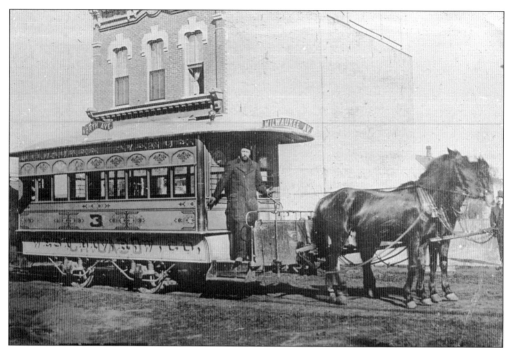

Chicago West Division Street Railway car 3 is on Milwaukee Avenue, an important angle street that originated as an Indian trail. Horsecars began running on Milwaukee in 1863 and were replaced by cable cars in 1890. Service was converted to electric streetcar between 1894 and 1906. (William C. Hoffman Collection, Wien-Criss Archive.)

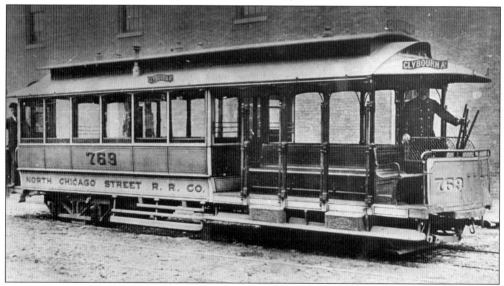

North Chicago Street Rail Road cable car 769 (built by Brownwell and Wight) is a "California" car, as it is half open and half enclosed, a style made popular in San Francisco. The "gripman" at front would use the levers to engage and disengage from a constantly moving cable running through a trough in the street between the two rails. Chicago's cable ran only four miles per hour downtown but up to 14 miles per hour in outlying areas. By comparison, San Francisco cable has a constant speed of 9.5 miles per hour. (William C. Hoffman Collection, Wien-Criss Archive.)

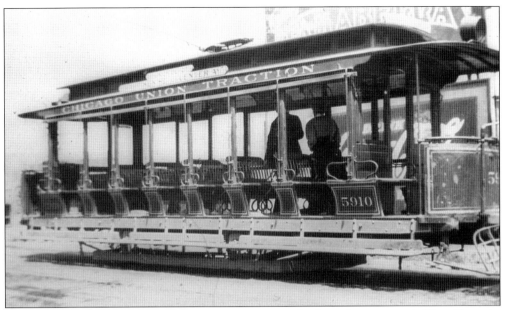

Chicago Union Traction 5910, an open streetcar, was built at the company's West Shops in 1900. The very first successful electric streetcars were used in Richmond, Virginia, in 1888. Early streetcars were patterned after contemporary cable cars, with the addition of motors and trolleys. Open cars like this one soon fell out of favor, since they could only be used in good weather. (William C. Hoffman Collection, Wien-Criss Archive.)

Chicago City Railway trolley 2169 heads eastbound on Seventy-Fifth Street at South Chicago Avenue around 1912. The railroad tracks at right (in the Grand Crossing neighborhood) were being elevated onto an embankment. Chicago had a very active grade separation movement in the early 1900s, as railroad crossings were both a traffic and safety hazard.

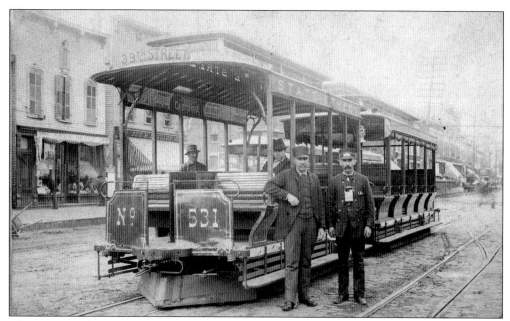

This rare 1880s photograph, taken from an albumen print mounted on a "cabinet card," shows a Chicago City Railway cable car train, gripman, and conductor, at State and Thirty-Ninth Streets. From 1882 to 1887, this was the south end of Chicago's first cable car line, which was then extended to Sixty-Third Street.

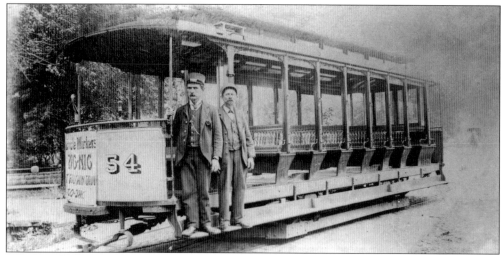

"Car 54, where are you?" The answer to that question in the late 1890s was on Chicago's north side. The Chicago Electric Transit Company began streetcar service on Lawrence Avenue in 1896, between Broadway and Milwaukee Avenues. This was part of an effort by traction magnate Charles Tyson Yerkes (1837–1905) to ring the north and west sides of the city with streetcar lines friendly to his interests, and to act as feeders to his North Chicago Street Railroad's cable cars. Yerkes opined that "you can carry a passenger about so far for five cents and no farther." With his numerous traction lines, Yerkes could charge multiple fares each way, thus maximizing his profits. Having more companies also meant he could sell more stock in each one. Yerkes eventually tired of Chicago and left town, and the Chicago Electric Transit Company fell victim to consolidation by 1900.

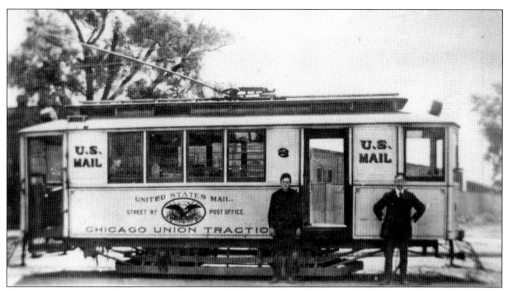

From 1895 until 1915, Chicago streetcars were used by the US Post Office to collect, sort, and transport mail until roads were improved to the point where trucks could do the job more efficiently. This picture was taken between 1900 and 1903. The man at right is motorman Harry Krygsman, who was still working for the Surface Lines as of 1937. Street railway post office (RPO) cars were used in about a dozen US cities. Chicago Union Traction car 8 was originally built for the Chicago & Proviso Street Railway in 1891. It was rebuilt for mail service in 1900. Car 8 was renumbered as H7 in 1913. After RPO service ended in 1915, it served as a work car for another 34 years and was retired in 1949. A sister car is now preserved at the Fox River Trolley Museum in South Elgin, Illinois.

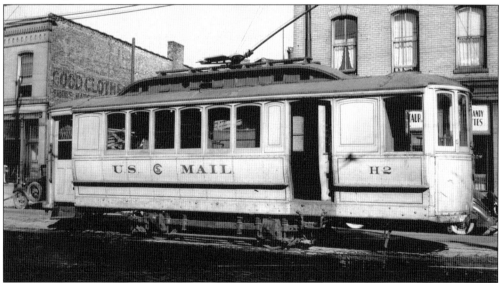

Except for a ceremonial event in 1946, the era of Chicago streetcar RPOs ended on November 21, 1915, less than two years into the Chicago Surface Lines era. This photograph of car H2 was taken on October 14, 1938, by Edward Frank Jr. at the Lincoln Avenue carbarn (or "station"), located at Wrightwood Avenue. The car was a tannish yellow gold, with gold letters and trimmings. H2 was scrapped in October 1942.

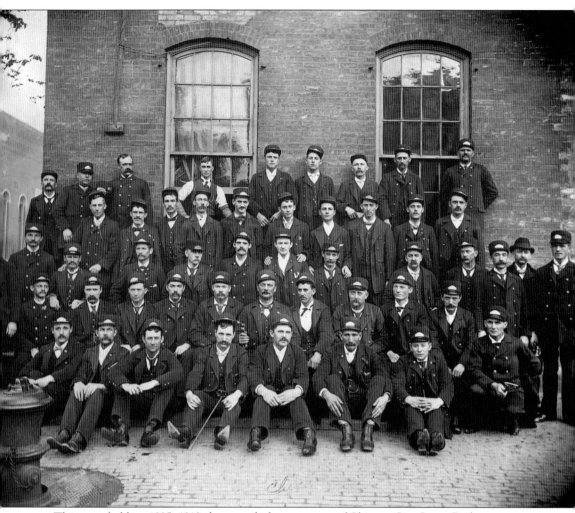

This remarkable c. 1895–1910 photograph shows a group of Chicago City Street Railway motormen and conductors, some with controller handles and switch irons for activating switches in city streets. It was a tough job, and they look like a bunch of hard men. There were drunks and robbers to contend and people who tried to ride without paying or caused a disturbance. Also, many car lines ran all night in all kinds of weather. Although Chicago was and is a diverse city, these highly skilled jobs were not integrated until October 1943, and only then due to wartime manpower shortages and federal pressure. The Chicago Transit Authority did not hire its first female bus driver until 1974.

It is a testament to the status transit workers once had that conductor William S. Atchison, pictured on the cover, posed for a formal portrait wearing his uniform. Granddaughter Debbie Becker, who provided this photograph, says he purchased a plot of land from self-styled "Captain" George Streeter, which the courts determined in 1918 did not belong to him. Thus, Atchison may have once been a squatter in the area of Chicago's Near North Side now known as Streeterville.

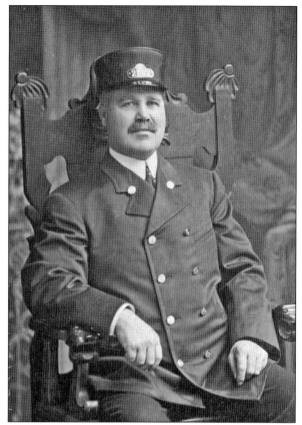

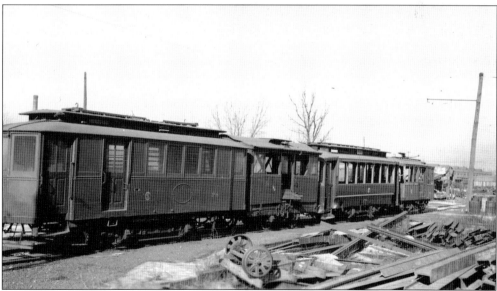

Chicago Surface Lines work cars P8, P251, P9, and S55 are in the scrap line at South Shops on May 12, 1943. These started life as early single-truck Chicago streetcars in the era from 1895 to 1915. They served out their remaining years shuttling supplies around Chicago's extensive streetcar network.

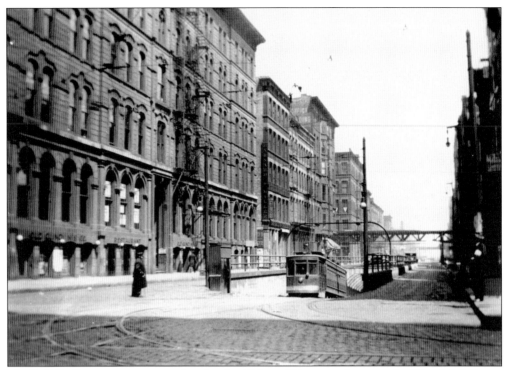

The LaSalle Street streetcar tunnel under the Chicago River, seen here north of Randolph Street around 1910, was used from 1871 until 1939. It then became an access point for the construction of the Dearborn-Milwaukee subway. It helped people escape the Great Chicago Fire shortly after it was opened. Chicago had three such tunnels, the others being at Washington and Van Buren Streets. Starting around 1915, there were plans to use these as the basis for streetcar subways that were never built. (Fred J. Borchert photograph, author's collection.)

This c. 1910 view looks east on Madison, between LaSalle and Clark Streets. The streetcar is "Big" Pullman 143, built in 1908 for the Chicago Railways. It became part of the Chicago Surface Lines in 1914. The Hotel Breevoort was located at 120 West Madison Street. (John F. Bromley Collection.)

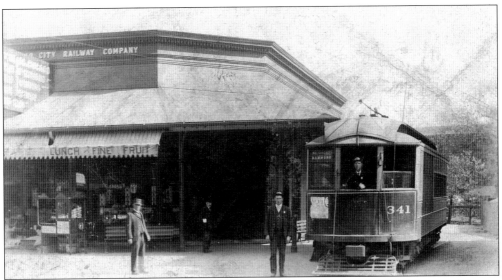

This rare, c. 1907 photograph shows the South Chicago City Railway's (SCCR) state-of-the-art waiting room at the Sixty-Third Street and Dorchester Avenue (known at the time as Madison Avenue). The facility was built in 1906 to serve riders transferring from the South Side "L" to the SCCR lines, including the latter's joint operation over the Hammond, Whiting & East Chicago into Indiana. "Interstate" trolley 341, built by the South Chicago City Railway in 1907, is in the turnaround loop at the station. In 1908, the South Chicago City Railway and its competitor merged to become the Calumet & South Chicago Railway. Car 341 was renumbered to 2855 in the Surface Lines era and became a salt spreader in 1948. It was retired in 1951.

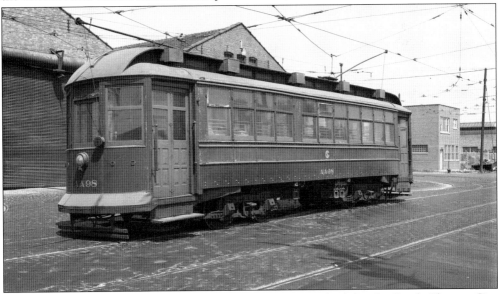

CTA salt spreader AA98 was originally Interstate car 2846, built by the South Chicago City Railway in 1907 and used in service to Indiana. One of the few "railroad roof"–type cars in Chicago, it is shown being operated for the very last time on May 25, 1958, at CTA's South Shops. Car 2846 was soon purchased by the Electric Railway Historical Society and eventually made its way to the Illinois Railway Museum, where it remains today. (Robert Selle photograph, author's collection.)

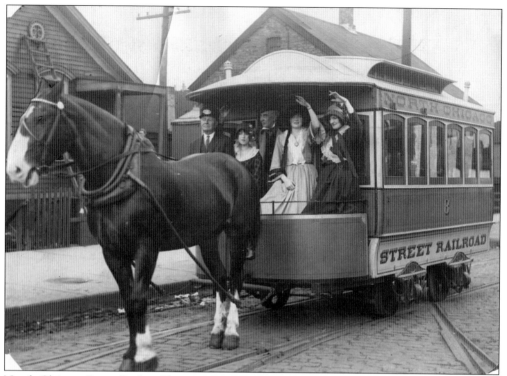

North Chicago Street Railroad horsecar 8 is pictured on January 2, 1926. The occasion was the opening of the new Cicero Avenue extension between Irving Park Road and Montrose Avenue. This car, built in 1859 by the John Stephenson Car Company, is preserved at the Illinois Railway Museum. It is called a "bob tail" car, because it has a short rear platform for boarding. It is fortunate that some older cars were kept for use in parades such as this.

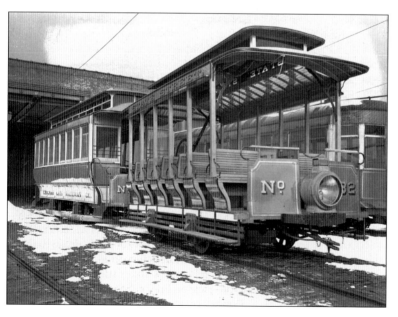

CSL built two cable car replicas (a grip and trailer) in 1934, probably using some original parts, and this is how they looked on February 25, 1938. Since then, car 532 has been on display at the Museum of Science and Industry, while 209 is at the Illinois Railway Museum.

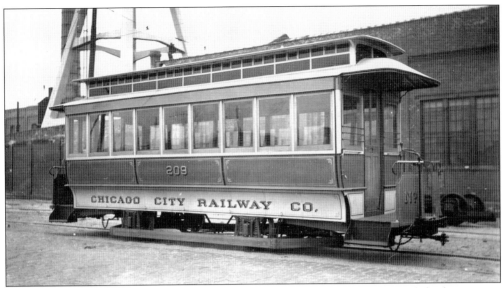

Cable trailer replica 209 is pictured on October 23, 1938, at South Shops. While this car was never actually used in service on Chicago's cable car system, it was built within the living memory of people who had worked on that system, last used in 1906. Hence, it still may have some authenticity. It was used in parades, hauled behind a streetcar. (Alfred Seibel photograph, author's collection.)

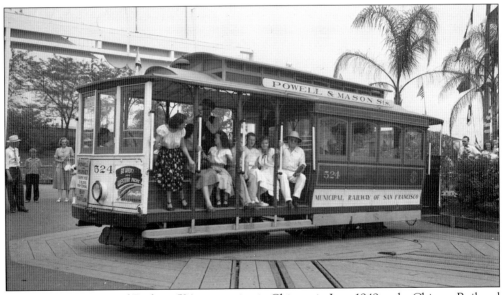

San Francisco Municipal Railway 524 is operating in Chicago in June 1949 at the Chicago Railroad Fair. This was the actual last cable car used in Chicago, on a short demonstration line sponsored by the Western Pacific Railroad. The 524 has been renumbered 24 and is still in service in San Francisco. It also made the last trip on the Washington–Jackson line on September 2, 1956, when the SF cable car network was consolidated. (L.L. Bonney photograph, author's collection.)

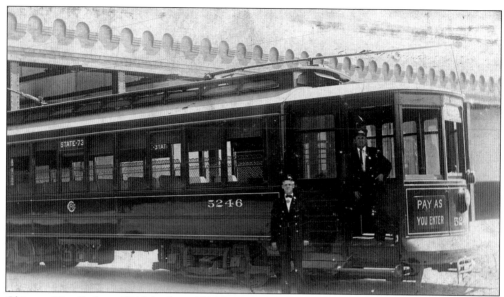

Chicago City Railway 5246, built in 1906 by the Brill-American Car Company, still has a shine in this view at the Seventy-Seventh Street Station (car house), on the Vincennes Avenue side. Motorman Jeff Powell sent this picture to his folks in Porter, Indiana, and wrote, "Best regards to all. I got a fine job up here. That is me in the door."

The controller cab of "Big" Pullman 144, built in 1908, is pictured on a mid-1950s fantrip. This car remains in operating condition at the Illinois Railway Museum. For the Chicago Surface Lines in the 1920s, it was full throttle ahead! (Chuck Wlodarczyk photograph, author's collection.)

Two

CONSOLIDATION
AND GROWTH

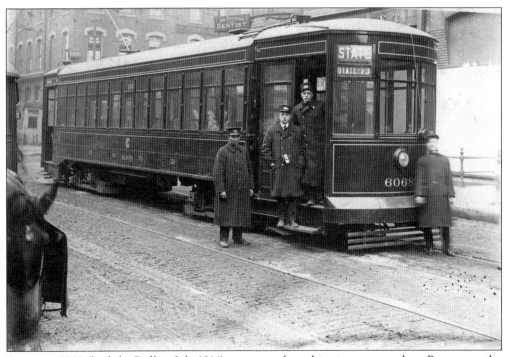

Streetcar 6068 (built by Brill in July 1914) was new when this picture was taken. But so was the Chicago Surface Lines, which unified the city's trolley operations that same February. While the streetcar tracks are paved in brick, the rest of this road, probably just north of the Loop, is made of dirt. At the left edge of the photograph, a horse with its nose in a feed bag is pulling a wagon.

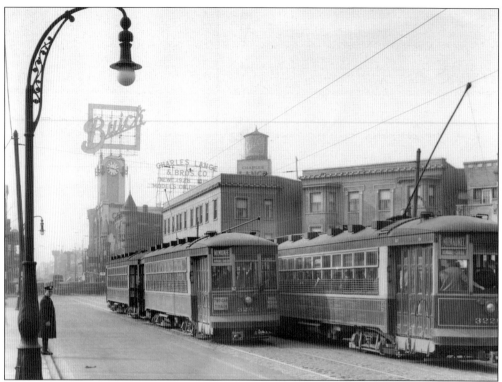

CSL 3204-3206 and 3228 are pictured in 1928, looking north along Milwaukee Avenue at Logan Boulevard from the middle of Logan Square. The Milwaukee car line ran all the way to the city limits (at Imlay Avenue, just north of Devon Avenue) starting in 1914 and played an important part in the development of Chicago's northwest side.

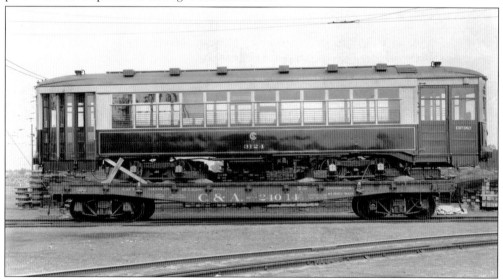

CSL 3124 is delivered from the J.G. Brill Car Company in December 1922. It was rebuilt as a one-man car in 1949. The 1920s were boom years for Chicago Surface Lines, and many new streetcars were ordered as ridership soared. Unfortunately, the Great Depression soon followed. (Krambles-Peterson Archive.)

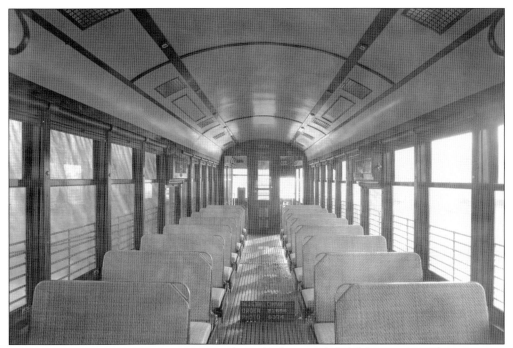

The as-new interior of CSL 3119 is seen at the Brill plant in Philadelphia in 1922. The seats were reversible, depending on which way this double-ended trolley was going, and were covered with rattan, a stiff material. (J.G. Brill photograph, Historical Society of Pennsylvania Collection.)

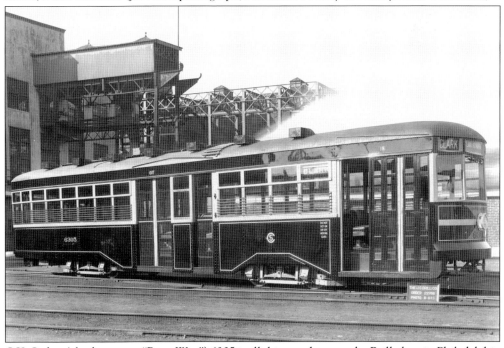

CSL Sedan (also known as "Peter Witt") 6305 is all shiny and new at the Brill plant in Philadelphia in 1929. These were fast, modern cars, and the last that Chicago bought before the streamlined era. (J.G. Brill photograph, Historical Society of Pennsylvania Collection.)

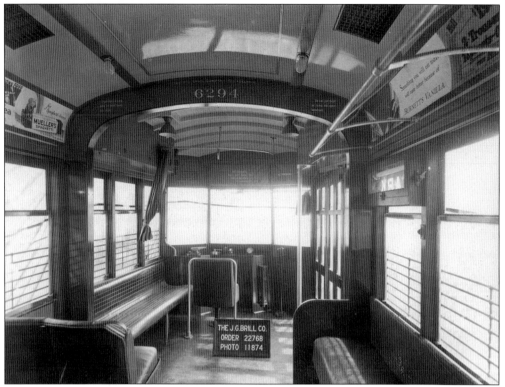

The interior of CSL 6294, shown as new, was photographed 1929 at the J.G. Brill plant. Brill built 33 of the 100 cars in this order, the most modern streetcars CSL had prior to the PCCs and their experimental forebears. (J.G. Brill photograph, Historical Society of Pennsylvania Collection.)

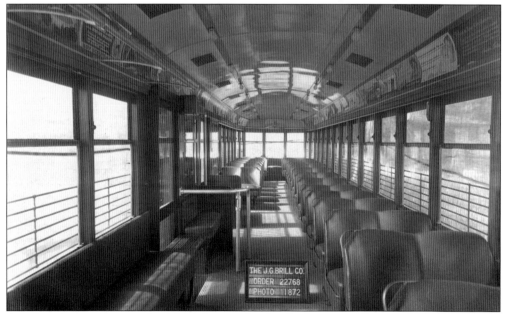

Another interior photograph of 6294 shows its leather bucket seats. These were very much state of the art in 1929. (J.G. Brill photograph, Historical Society of Pennsylvania Collection.)

The Roosevelt Road extension to the World's Fair site is under construction in this view from June 24, 1933. The Illinois Central Electric suburban station lies between here and what is now called the Museum Campus. The fair, called "A Century of Progress," celebrated the centennial of Chicago's founding and drew millions during the depths of the Great Depression. This gave Chicago an economic boost that other cities tried to copy in the 1930s, but none were as successful.

It is August 1, 1933, and the World's Fair extension along Roosevelt Road has been completed. Mayor Edward J. Kelly, posing for pictures, is at the controls of the first service car over the viaduct. Kelly succeeded Anton Cermak as mayor earlier that year after the latter was assassinated in Miami. There is still controversy as to whether assassin Giuseppe Zangara was trying to shoot Cermak or nearby president-elect Franklin D. Roosevelt. By the time this picture was taken, Zangara had already been convicted and executed. The Roosevelt Road extension remained in use until April 12, 1953.

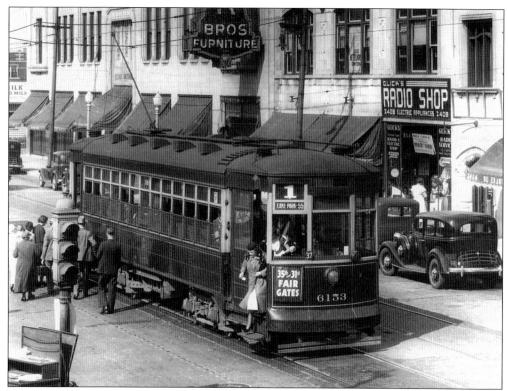

CSL 6153 is heading east on Devon Avenue near Western Avenue on Through Route 1 (Cottage Grove Avenue–Broadway) around 1933–1934. Starting in 1932, these cars ran to Devon and Kedzie Avenues, a mile west of here. Car 6153 was built by CSL in 1919 and is part of a series nicknamed the "Odd 17." These were mainly streetcars built to replace others that were lost in accidents or fires. (Krambles-Peterson Archive.)

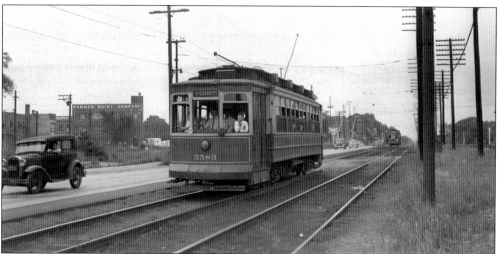

CSL 5583 is running in interurban-style "side of the road" trackage on Vincennes Avenue near 104th Street, heading toward 111th Street and Sacramento Avenue on Route 8–Halsted. As was often the case in those days (the 1940s), close headways mean another car is in sight. Car 5583 was built by Brill in 1907 for the Chicago City Railway.

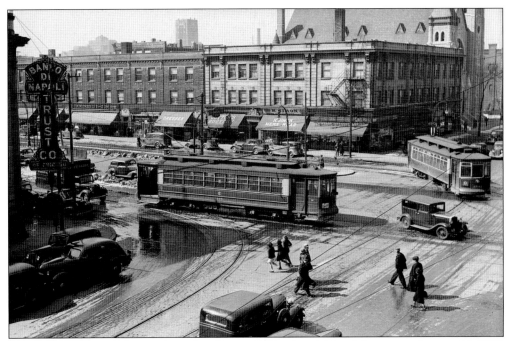

CSL "Big" Pullman 183 is eastbound on Roosevelt Road at Ashland Avenue on January 15, 1937, while 5502, an Ashland car, is turning west onto Roosevelt Road to jog over to Paulina Street. There was a portion of Ashland that streetcars were not allowed to operate on, hence the change in routing. The Chicago Park District controlled the nearby boulevards, where transit service was provided by the Chicago Motor Coach Company's buses. Immanuel Lutheran Church is in the background. It is one of the few non-Catholic Chicago churches that has operated continuously for over 150 years. Its present building was completed in 1888.

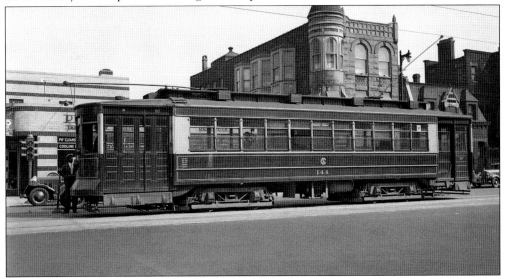

"Big" Pullman 144 is running on Cermak Road in this September 19, 1934, photograph. A 1930 Checker Model M taxicab is at left. The auto on the right looks like an early-1930s Auburn, built by Auburn-Cord-Duesenberg in Auburn, Indiana. The 144 is now preserved in operating condition at the Illinois Railway Museum in Union.

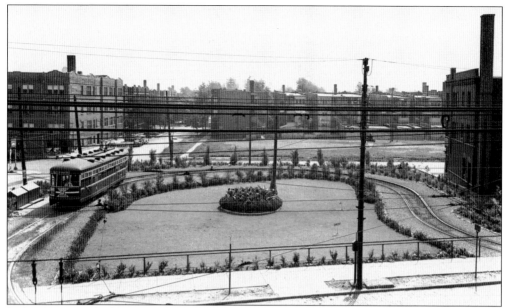

Sedan 3342 rounds the corner into a loop at Clark Street and Arthur Avenue on Chicago's North Side. The photographer is looking east from the second floor of Devon Station (or car house). CSL beautifully landscaped many of its streetcar loops. There was plenty of available labor in the 1930s to do this kind of work. Now many are covered with utilitarian asphalt, which is easier to maintain. (CSL photograph, Krambles-Peterson Archive.)

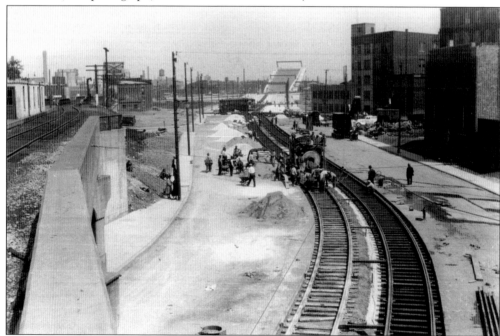

The two halves of Ashland Avenue were connected in 1936 by a new bridge over the Chicago River, one of the last major streetcar line extensions by CSL. This picture, showing the construction work, was taken from the Chicago & North Western passenger station at Clybourn Avenue looking north. (Edward Frank Jr. photograph, author's collection.)

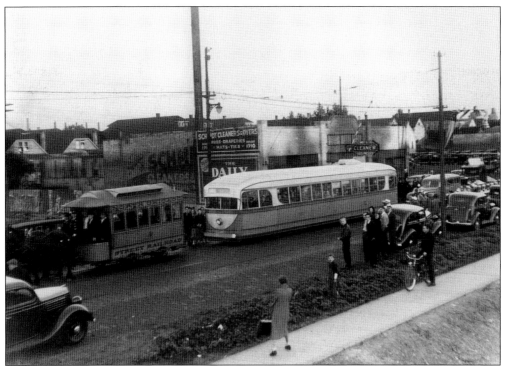

It is time for a parade on June 11, 1936, celebrating the 100th anniversary of South Chicago and Calumet. "Old" meets "new" here at 8537 South Commercial Avenue. North Chicago Street Railroad "Bombay roof" horsecar 8 is ahead of experimental 1934 Brill pre-PCC car 7001. Ironically, the older car survives at the Illinois Railway Museum, while 7001 was scrapped in 1959.

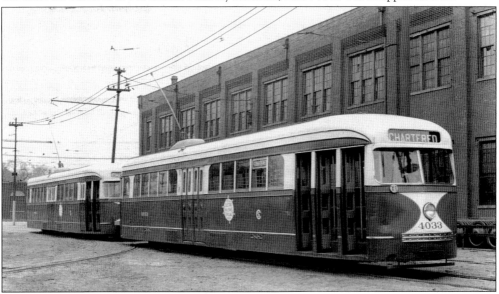

CSL 4033 and 7002 are shown on Seventy-Eighth Street by South Shops on October 23, 1938, during an excursion. This trip (sponsored by the Chicago Surface Lines) helped recruit many members to the fledgling Central Electric Railfans' Association, which then prospered. (Malcolm D. McCarter Collection.)

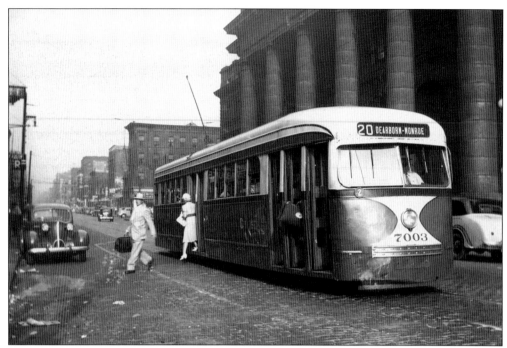

CSL prewar PCC 7003 lets passengers off in front of the old Chicago & North Western station on Madison Street just west of the Loop. The late-1930s Packard at left helps date the picture. It looks like there was a bit of a litter problem here.

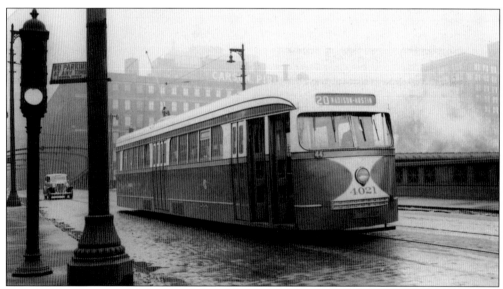

CSL 4021 heads west at Madison and Canal Streets in the 1940s. The only prewar Chicago PCC that survives, this car is now at the Illinois Railway Museum, where it will hopefully one day be restored. (B.H. Nichols photograph, author's collection.)

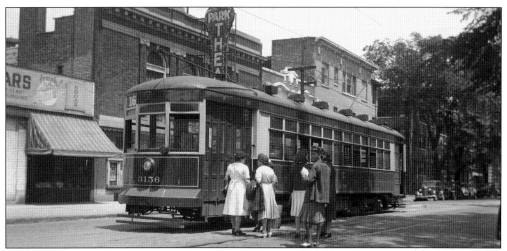

Riders wait to board the rear of CSL 3156 at Lake Street and Austin Boulevard in the late 1930s. This car was on Through Route 16 (State Street–Lake Street). The Park Theater, behind the car, closed around 1952, probably due to competition from television. Car 3156 was built by Brill in 1922 and is known as a "169" or "Broadway-State" car. It was converted to one-man operation in 1949.

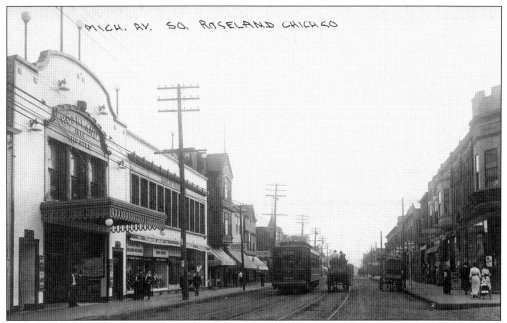

The up-and-coming Roseland neighborhood, on Chicago's far south side, was already enjoying the benefits of improved transportation when this 1914 photograph was taken at Michigan Avenue and 113th Street. The creation of the Chicago Surface Lines meant that local residents now had a one-seat ride into downtown Chicago, as the Cottage Grove trolley was through-routed here. Note that there are very few automobiles, and horse-drawn wagons are still prevalent (and would not completely disappear from Chicago's streets until the 1950s). Car 5609 was built for the Chicago City Railway by Brill in 1909. The brand-new Roseland Theatre is advertising *The Spoilers*, a nine-reel silent film about the 1898 Alaskan Gold Rush. Both the film and the building still exist as of 2017. (P.L. Huckins photograph, authors' collection.)

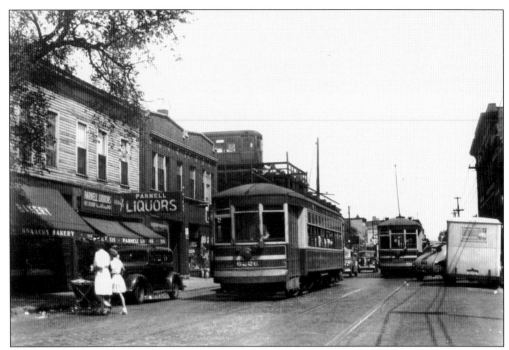

This picture shows the end of the Normal Park "L" on Sixty-Ninth Street between Parnell and Normal Avenues in the 1940s. CSL 6226 and 6236 are running on Route 67-69-71. The Normal Park Branch was built with the intention of extending it south, but this did not happen, and it was abandoned in 1954. This was the farthest point south that the rapid transit system reached until the Dan Ryan Expressway extension opened in 1969. (Edward Frank Jr. photograph, author's collection.)

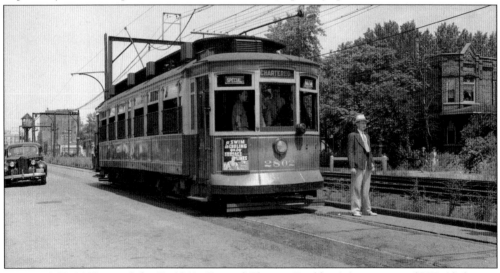

Here is CSL 2802 on a July 13, 1941, Central Electric Railfans' Association (CERA) fantrip alongside the South Chicago Branch of the Illinois Central Electric suburban tracks. The nattily dressed man is George Krambles (1915–1999), CERA member no. 1, who later became general manager of the CTA. Car 2802 was built by St. Louis Car Company in 1901 and is known as a "Robertson Rebuild." A c. 1940 Packard prepares to go around the car. (Hochner photograph, author's collection.)

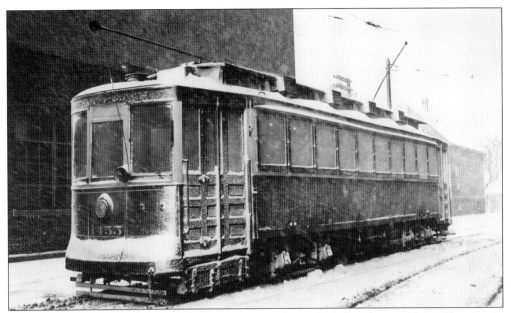

CSL 1455 battles the elements in this wintry scene. It was built by Chicago Union Traction in 1900 and called a "Bowling Alley" car due to its sideways seating. It became a salt car in 1948 and was retired in 1951. Visibility must have been difficult, as these early streetcars had no defrosters or windshield wipers. (Joe L. Diaz photograph, author's collection.)

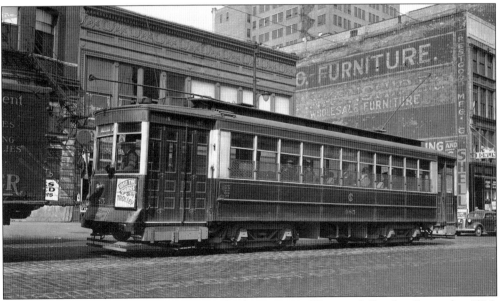

CSL "Little" Pullman 985 is in traffic at Wabash Avenue and Roosevelt Road in September 1936. It was built in 1910 and looks to be on Through Route 3 (Lincoln–Indiana), which operated from 1912 to 1951. Through routes combined two streetcar lines and carried passengers across the city. Some were as long as 20 miles. This car was slightly shorter than the "Big" Pullmans.

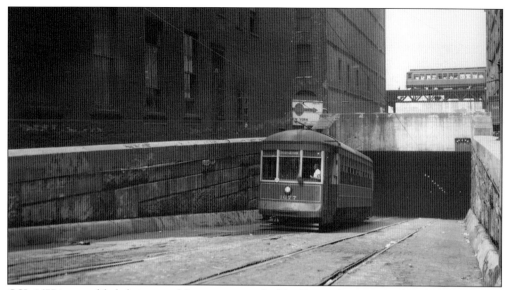

CSL 1677 is most likely being used for training in the Van Buren Street tunnel under the Chicago River in this photograph, with the Metropolitan "L" in the background. Car 1677 was built by Chicago Railways in 1912 as an improved version of the Pullmans of a few years earlier. (Joe L. Diaz photograph, author's collection.)

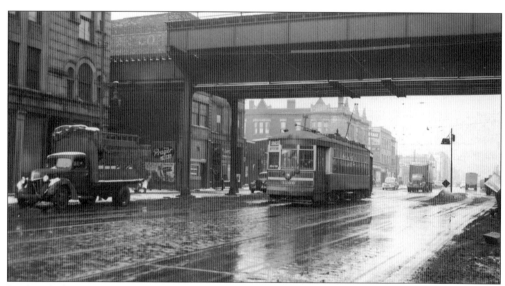

In this slushy winter scene, car 3266 is southbound on State Street below Fifty-Ninth Street on the 59–61 line, passing under the Englewood Branch of the South Side "L". There is a safety island behind the streetcar, which offered riders some protection from errant cars and trucks, since they boarded in the middle of the street. (Joe L. Diaz photograph, author's collection.)

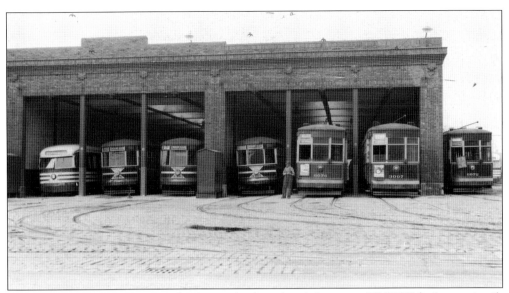

This mid-1940s lineup of cars at Kedzie Station (car house) includes prewar PCC 7019 (in "tiger stripes"), some Sedans, and other red cars. (Robert V. Mehlenbeck photograph, author's collection.)

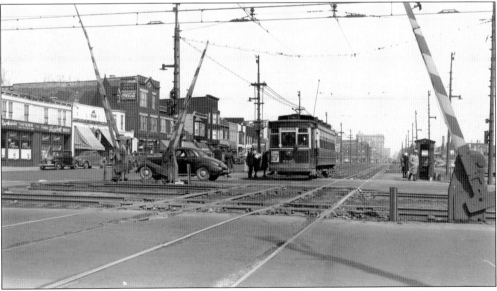

Southbound Stony Island car 5628 prepares to trundle across the Illinois Central Electric tracks at Seventy-First Street on its way to Ninety-Third Street and South Stony Island Boulevard in this c. 1940 view. The Stony Island car line had extensive sections of private right-of-way, similar to some Boston streetcar lines that survive to this day. (Joe L. Diaz photograph, author's collection.)

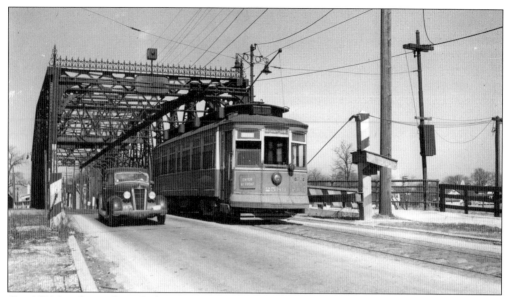

Car 2589 heads north on Indiana Avenue near 134th Place, crossing the Little Calumet River. There is a hand-written sign on the car saying "Keep to Right," warning drivers not to try passing on the left on this single-track bridge. CSL's Riverdale line, on Chicago's Far South Side, was an early victim of bus substitution on September 9, 1946, as it had very light ridership. (Joe L. Diaz photograph, author's collection.)

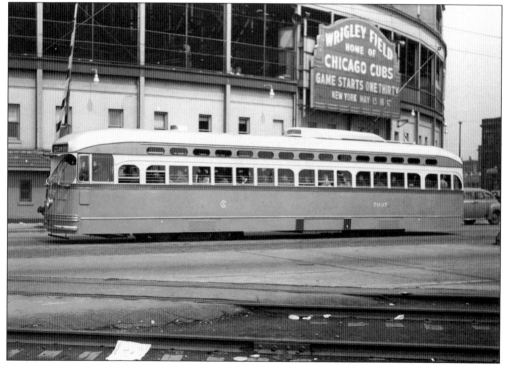

CSL postwar PCC 7037 heads north on Clark Street near Addison Street and passes Wrigley Field in May 1947. The Cubs were scheduled to play the New York Giants at their next home stand and would go on to lose all three games in that series.

Three

TROLLEYS TO THE SUBURBS

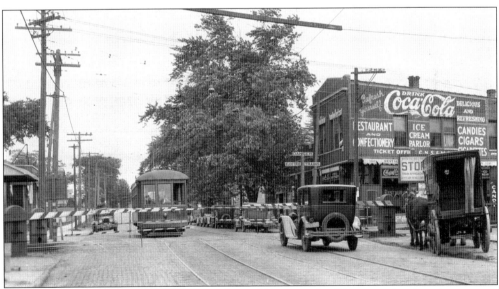

Westbound Evanston Railways car 9 is on Central Street at the "L" prior to its elevation onto an embankment. Elevation work began in August 1928, so this picture cannot be later than that. Note the horse-drawn carriage at right. (William C. Hoffman Collection, Wien-Criss Archive.)

Evanston Railways car 4 is at Central Street near Bennett Avenue, heading westbound. This area looks much the same today. (William C. Hoffman Collection, Wien-Criss Archive.)

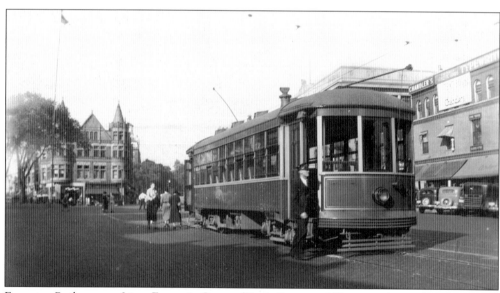

Evanston Railways car 3 is at Fountain Square (Davis Street and Sherman Avenue) in downtown Evanston in October 1935, about a month before streetcar service was abandoned. Motorman Charles Peterson is about to change ends for the trip south. Evanston wanted to repave several streets and expected the financially strapped trolley operator to pay for rebuilding its own track. It was easier and cheaper to simply replace the streetcars with buses. (William C. Hoffman Collection, Wien-Criss Archive.)

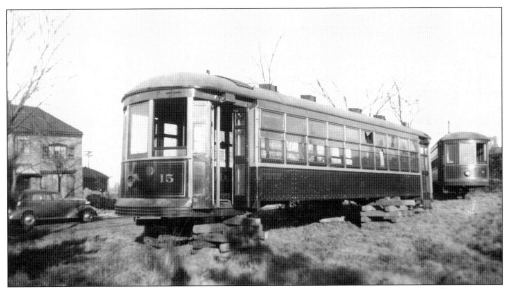

The body of Evanston Railways car 15 sits alongside Chancellor Street in Evanston after streetcar service ended on November 9, 1935. Two former Evanston Railways cars were used to build the Diner Grill, which opened in 1937 at 1635 West Irving Park Road in Chicago's Lakeview neighborhood. One car was severely damaged by fire on Christmas Eve 2016, but there are plans to restore it. Those are the only Evanston Railway cars that have survived. (William C. Hoffman Collection, Wien-Criss Archive.)

Chicago & Calumet District (C&CD) car 80 is in service on the Whiting–East Chicago route, a joint operation between CSL and C&CD predecessor Hammond, Whiting & East Chicago Railway that ended on June 9, 1940. The view looks south on Indianapolis Boulevard at Calumet. This car was nearly identical to Chicago rolling stock and reflects how closely the two operators worked together.

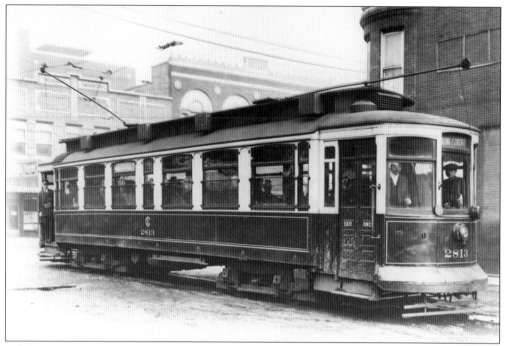

While practically all CSL car service ended at the Chicago city limits, here is CSL 2813 in Indiana, on the jointly operated Hammond, Whiting & East Chicago line. This picture was taken on Exchange Avenue, just east of Indianapolis Boulevard, looking west in East Chicago.

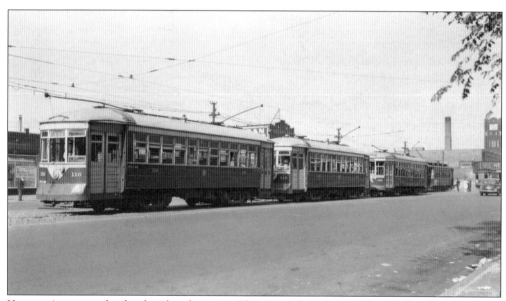

Kenton Avenue is the dividing line between Chicago and Cicero on Cermak Road, and this was the east end of the long Chicago & West Towns (C&WT) LaGrange line. Here are cars 116, 115, and 158. Riders could change here to go east on Surface Lines Route 21. (Joe L. Diaz photograph, author's collection.)

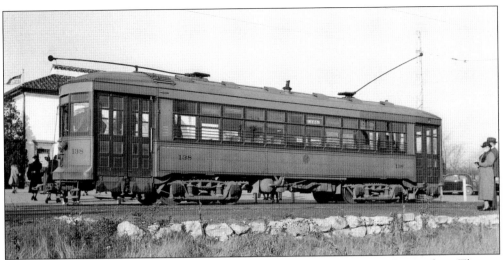

C&WT 138 arrives at the Brookfield Zoo on July 22, 1938, on the busy LaGrange line. The zoo first opened in 1934, and streetcar service ended in April 1948. Trolleys ran through the south parking lot. (John F. Bromley Collection.)

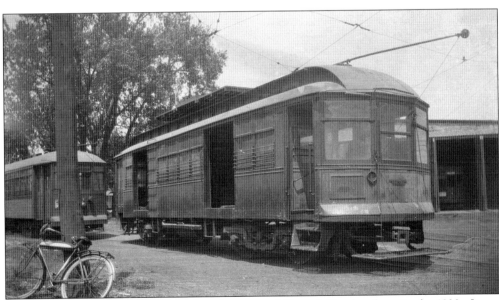

C&WT car 15 is pictured at the Harlem Avenue and Cermak Road carbarn in the 1930s. It was built by Pullman in 1897 as Suburban Railroad 512, renumbered and rebuilt in 1927, and scrapped in 1948. Photographer Edward Frank Jr.'s bicycle, at left, appears in many of his images. Rather than ride the trolleys, he rode his bike all over Chicagoland to save money for film.

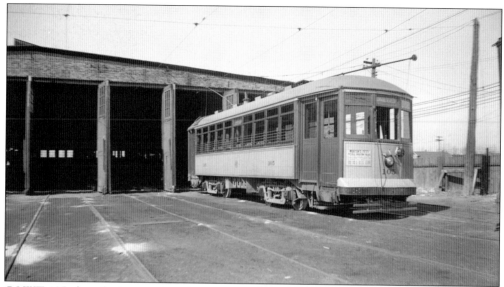

C&WT 105, described as tan in color, poses in front of the North Riverside carbarn on April 28, 1939. This car was built by McGuire-Cummings in 1915. (Gordon E. Lloyd photograph, author's collection.)

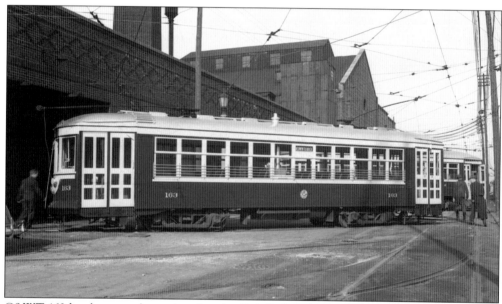

C&WT 163 has been newly repainted at the Oak Park carbarn on April 23, 1939. There was a CERA fantrip on the West Towns on this date. Car 163 was built by the Cummings Car Company in 1927. This facility survived into the 1980s, when it was demolished to build a Dominick's Finer Foods supermarket. A Pete's Fresh Market now occupies the location. (LaMar M. Kelley photograph, author's collection.)

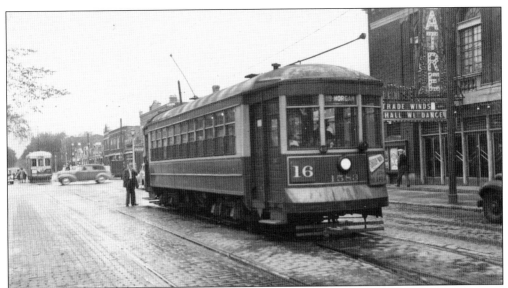

CSL 1583 is sitting in front of the old Park Theatre at 5962 West Lake Street in Chicago's Austin neighborhood. C&WT car 145 (at left) is in Oak Park, on the other side of Austin Boulevard. Car 1583 is working Through Route 16 (State Street–Lake Street), which went to 119th and Morgan Streets, a distance of close to 25 miles from here. (Stephen D. Maguire photograph, author's collection.)

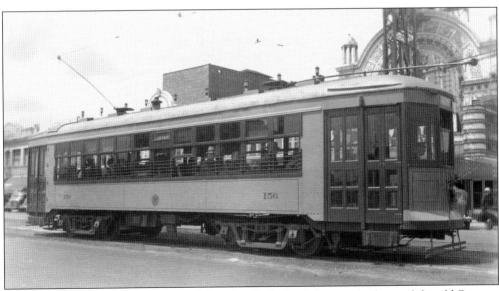

C&WT 156 is eastbound on Cermak Road at Ridgeland Avenue in front of the old Berwyn Theatre, which opened in 1924. It was damaged by fire in 1990 and demolished. This photograph was probably taken not long after the theatre was modernized in 1936. Car 156 was built by Cummings Car Co. in 1927, rebuilt in 1942 and scrapped in 1948. (Edward Frank Jr. photograph, author's collection.)

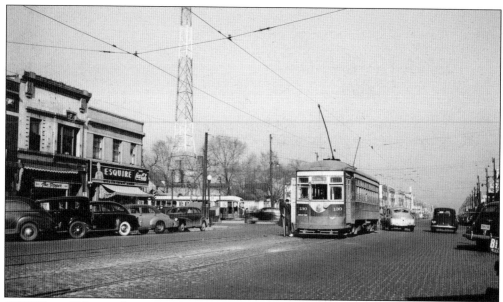

C&WT car 130 is at the east end of the Madison Street line at Austin Boulevard on March 31, 1946, while a Chicago Surface Lines prewar PCC sits at the nearby loop. This is the border between Chicago and suburban Oak Park. (Don Ross photograph, author's collection.)

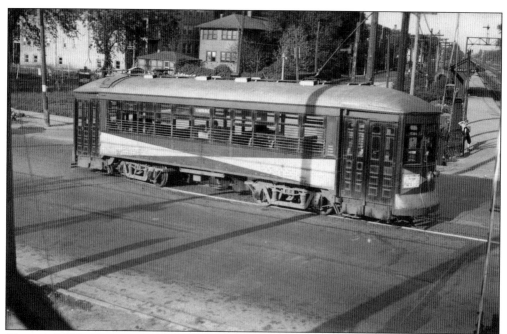

Chicago & West Towns car 106 was built by McGuire-Cummings in 1915. It was dismantled in 1943. Here, it is turning from northbound Harlem Avenue to eastbound Stanley Avenue in 1936, having just crossed the Burlington Railroad in Berwyn. Commuter rail service continues at this station today under the auspices of Metra. Pace suburban bus route 302 makes this same turn today, more than 80 years later.

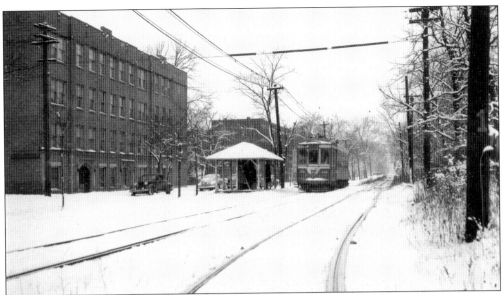

C&WT 152 is heading east on a private right-of-way on the busy LaGrange route. The exact location is about 82 Park Place in Riverside. Car 152 has just crossed the DesPlaines River, passing through the Forest Preserves after stopping at the Brookfield Zoo. From here, it will turn north on Woodside Drive, which changes into DesPlaines Avenue, before heading east on Twenty-Sixth Street. These covered wooden shelters were long a feature of the West Towns, and a couple of recreations like this are still in use by the Pace suburban bus service, which replaced C&WT. The large apartment building at left is still there as of this writing. (Joe L. Diaz.)

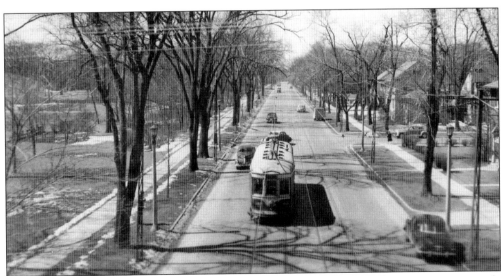

In this 1940s view, C&WT 151 is heading east on Lake Street in River Forest, at approximately 7820 West. The photographer stood on the nearby Soo Line embankment. (William C. Hoffman Collection, Wien-Criss Archive.)

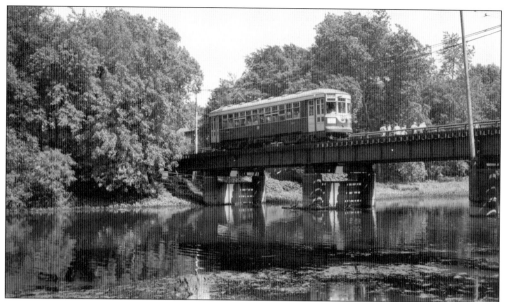

C&WT 141 is westbound on the LaGrange line, crossing the DesPlaines River in Riverside during the 1940s. After a short stretch of private right-of-way in the Forest Preserves, it will cross First Avenue and make its next stop at the Brookfield Zoo, which opened in 1934. Car 141 is the only piece of West Towns rolling stock to be preserved.

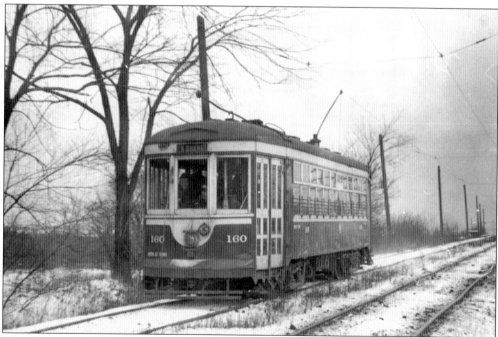

The Chicago & West Towns had some private right-of-way in the western suburbs. Car 160 is shown at speed near LaGrange in December 1945. If this line had survived, it would now be called "light rail."

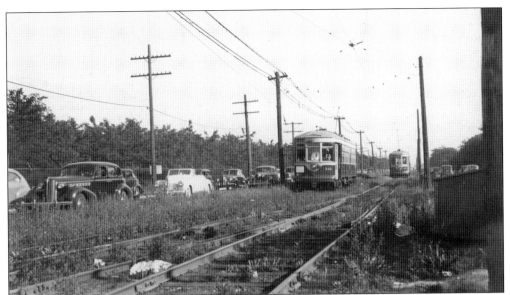

C&WT 141 approaches the photographer on LaGrange line's private right-of-way. The only West Towns car saved, 141 had been reduced to a storage shack when it was purchased by the Electric Railway Historical Society in the late 1950s. It went to the Illinois Railway Museum in 1973 and has now been restored to operating condition. (Thomas H. Desnoyers photograph, Wien-Criss Archive.)

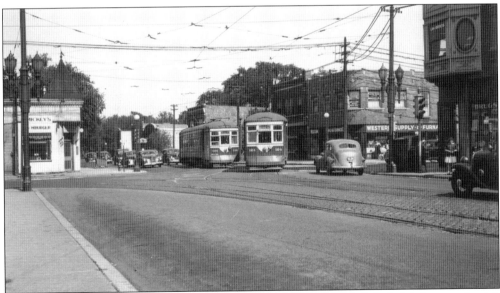

C&WT 134 and 124 pass on Madison Street at Harlem Avenue in Oak Park. Madison took a job at this point, which has since been straightened. This view faces east, and the building at right still stands. (Joe L. Diaz photograph, author's collection.)

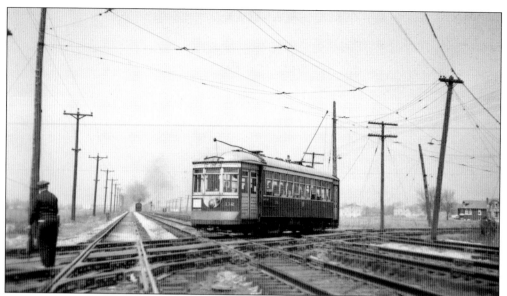

C&WT 112 crosses the Indiana Harbor Belt Railroad in LaGrange while a steam engine approaches in the distance. The train must not be going very fast, as the trolley men do not seem too disturbed by its presence. (William C. Hoffman Collection, Wien-Criss Archive.)

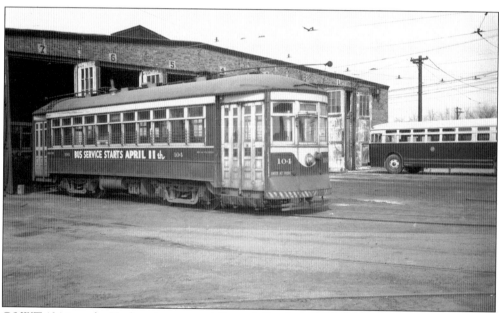

C&WT 104 is at the Harlem Avenue and Cermak Road carbarn on April 3, 1948, less than two weeks before the end of streetcar service. One of the replacement "Old Look" buses is at right. Some of those buses were still on the property in the early 1980s, when operations were taken over by the Regional Transportation Authority. Local bus service in Chicago's western suburbs is now provided by Pace. (C. Edward Hedstrom photograph, author's collection.)

Four

TROLLEYS ON THE "L"

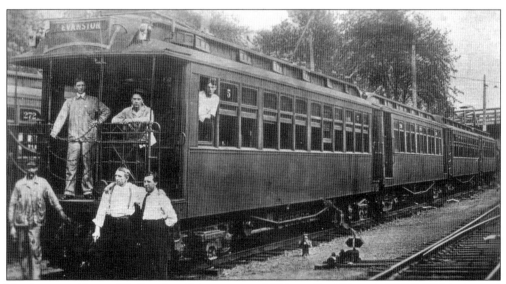

Northwestern Elevated Railroad car 5, later renamed Chicago Rapid Transit (CRT) 1005, is pictured in the old Central Street yard in Evanston sometime between 1908 and 1912. This branch of the "L" used overhead wire until 1973. Here, the line was elevated in the late 1920s.

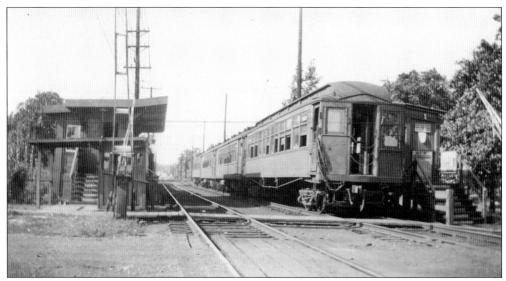

A northbound train is shown at Isabella Street on the Evanston line before 1943. This station closed on July 16, 1973. The State Street Subway opened in 1943, and all-steel rapid transit cars were diverted for use there. Wooden "L" cars were not allowed in the subway due to fire safety concerns. This, in turn, was prompted by accidents and fires on the New York subway system. The 1972–1978 version of the *Bob Newhart Show* showed the famed comedian getting off an "L" train at this station in the opening credits. (William C. Hoffman Collection, Wien-Criss Archive.)

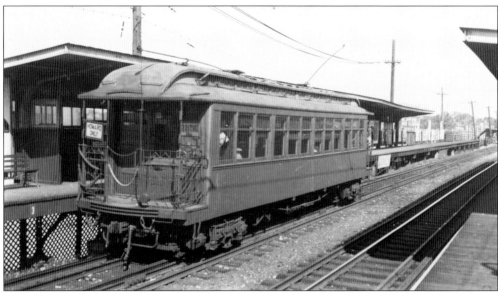

CRT gate car 1029, originally numbered 29, was built by Pullman in 1899 for the Northwestern Elevated Railroad. It is seen here heading south at Davis Street on the Evanston Branch. Sister car 24 has been restored at the Illinois Railway Museum. (William C. Hoffman Collection, Wien-Criss Archive.)

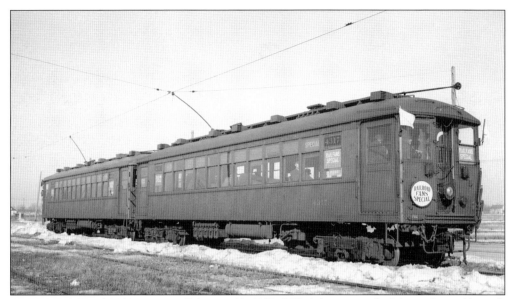

CRT cars 4317 and 4401 pose on a February 12, 1939, CERA fantrip on the Mount Carmel branch of the Chicago, Aurora & Elgin interurban, which ran near Mannheim Road north of Cermak Road in suburban Broadview. Although these were not interurban cars per se, they did occasionally get around to parts of the interurban system. Their top speed was about 45 miles per hour. The Illinois Department of Transportation has proposed extending CTA rapid transit service to this approximate location. (R.J. Anderson photograph, author's collection.)

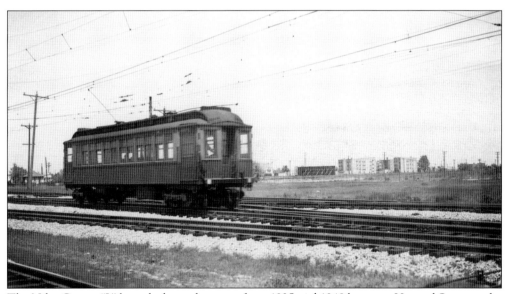

The Niles Center "L" branch shown here ran from 1925 and 1948 between Howard Street at the northern border of Chicago and Dempster Street in Skokie. Chicago's rapid transit lines depended on walk-in traffic from the neighborhoods. Unfortunately, this suburban area was not built up until after World War II. These tracks were part of the North Shore Line's Skokie Valley Route, which continued to Milwaukee. After the interurban quit in 1963, the CTA bought five miles of this line and restored service the following year as the *Skokie Swift*, today's Yellow Line.

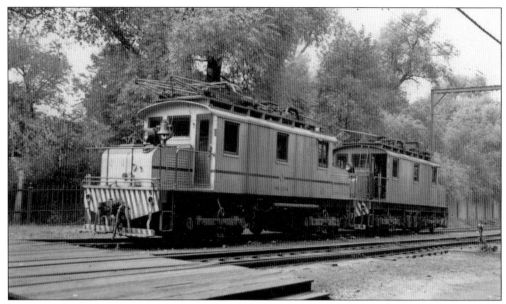

CTA electric locomotives S-104 and S-105, shown here at the old ground-level Buena Avenue (pronounced "bu-wennah" by Chicagoans) Yard between Irving Park and Wilson Avenue, once hauled freight on the North Side "L". Freight service was a holdover from earlier days, when this was originally part of the Milwaukee Road. The Chicago Transit Authority leased these tracks and purchased them outright in the early 1950s. Freight operations ended on April 30, 1973. (Joe L. Diaz photograph, author's collection.)

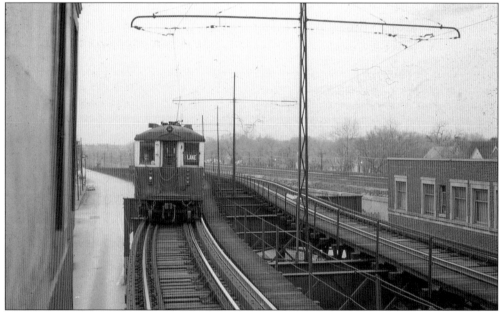

The outer two-and-a-half miles of the Lake Street "L" (today's CTA Green Line) ran at ground level with overhead wire until October 28, 1962, when this stretch was put onto the adjacent Chicago & North Western embankment. Here, eastbound CTA 4297 goes up the ramp to the Laramie Avenue Station on May 7, 1961, where it will change over to electrified third rail. (Charles L. Tauscher photograph, Wien-Criss Archive.)

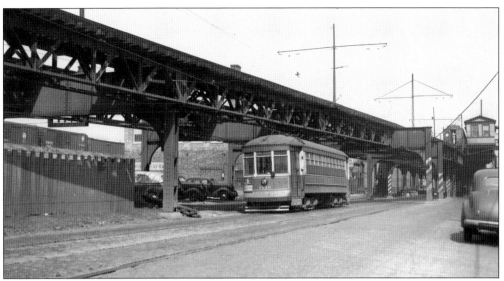

CSL 1616 heads west on Lake Street, while running parallel to a ramp just west of Laramie Avenue that will bring the Lake Street "L" down to ground level. Both lines will then run side-by-side for a few blocks. At rear, an eastbound "L" train is changing over from overhead wire to third rail. Streetcar service on Lake Street ended in 1954. By late 1961, the "L" power changeover point had been moved farther west as part of the process that eventually relocated this portion of "L" to the nearby Chicago & North Western embankment. (Joe L. Diaz photograph, author's collection.)

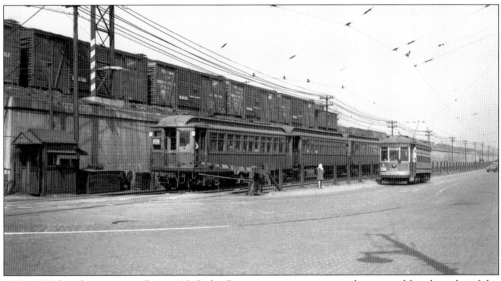

CSL 1627, heading west on Route 16–Lake Street, prepares to cross the ground-level tracks of the Lake Street "L" at Pine Avenue, one block east of Central Avenue. It will then proceed just over half a mile before turning back at Austin Boulevard. This is also where Lake Street itself takes the same jog. The street west of here for a few blocks was renamed Corcoran Place in 1964, after Paul Thomas Corcoran (1905–1964), who served as 37th Ward alderman from 1955 until his death. He was a close ally of Mayor Richard J. Daley. (Joe L. Diaz photograph, author's collection.)

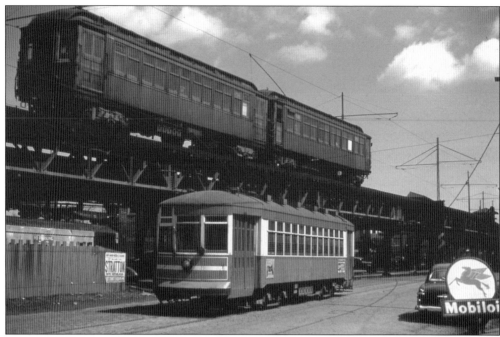

In April 1952, CTA one-man streetcar 3136 heads west on Lake Street, just west of Laramie Avenue, while a wooden two-car "L" train heads east, both under trolley wire. (George Krambles photograph, Krambles-Peterson Archive.)

Here is an interesting 1940s streetscape that could not be duplicated today, looking east from South and Austin Boulevards, on the eastern edge of Oak Park. The Lake Street "L", where it ran on the ground, had a very narrow right-of-way. The buses are Chicago Motor Coach (CMC) TD-4502s at the western terminal of Route 31–Washington Boulevard, in their original 1940 paint jobs. The Chicago Transit Authority purchased the CMC assets and routes on October 1, 1952, which finally brought about the long-sought dream of local transit unification in Chicago. On the Chicago side, this was called Lake Street when this picture was taken, but it is now Corcoran Place.

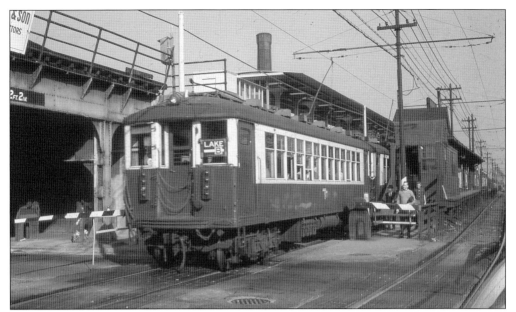

A westbound train of CTA 4000s departs the Ridgeland Avenue Station in October 1962, shortly before the Lake Street line was elevated. The ground-level operation on the western two and a half miles of this "L" route may have been difficult from an operational standpoint, with numerous manually operated grade crossings, tight clearances, and blind spots, but it was certainly photogenic. (Charles L. Tauscher photograph, Wien-Criss Archive.)

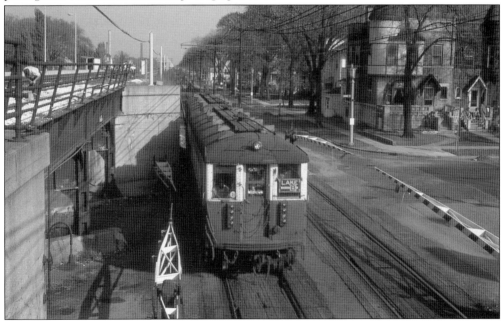

A westbound Lake Street B train is pictured on South Boulevard at Home Avenue in Oak Park in October 1962. The photographer's vantage point was a stairway leading to the nearby Chicago & North Western commuter station. Relocation of the "L" onto the embankment was a win-win for all the stakeholders involved. CTA trains run faster and safer, as does street traffic, and more parking spaces were created. (Charles L. Tauscher photograph, Wien-Criss Archive.)

This c. 1949 photograph shows the east end of the Marion Street "L" Station on the Lake Street line in suburban Oak Park. Other than the high-level platform boarding, there was not much difference between this operation and a streetcar.

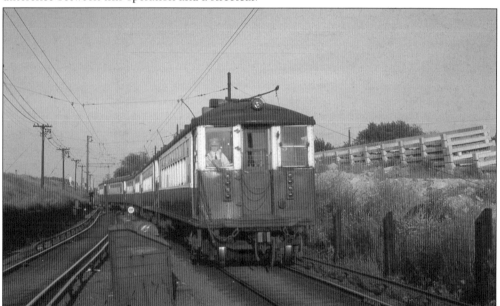

A westbound Lake Street train is at the end of the line in suburban Forest Park in August 1962. At right, construction is already underway for a new portion of embankment that will support a rail yard, the first proper yard the Lake Street "L" ever had. Prior to this, cars were stored farther east, partly on a third center track on the "L" structure. (Charles L. Tauscher photograph, Wien-Criss Archive.)

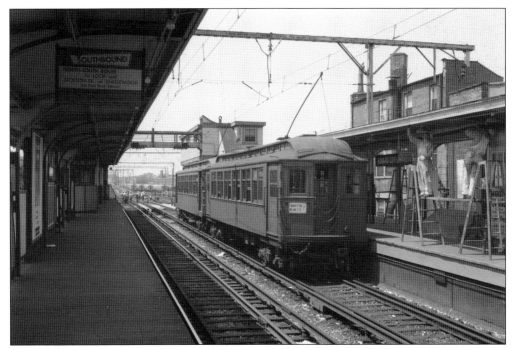

A northbound two-car Evanston shuttle train is held up momentarily at Howard Street in the 1950s, as track work is going on up ahead. The rear car is 1766. Don Ross says, "1756 through 1768 were built by Jewett Car in 1903 as Northwestern Elevated Railway 756 through 768. They were renumbered 1756 through 1768 in 1913 and became CRT 1756 through 1768 in 1923." Wooden cars last ran in Evanston in 1957. Note that the station is also being painted.

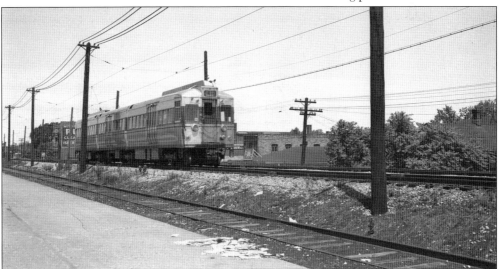

CTA's articulated "Doodlebug" 5003 is pictured at Main Street in Evanston. This was one of four experimental articulated "L" cars built in 1947–1948, which were patterned after similar cars (nicknamed the "Bluebirds") built for Brooklyn-Manhattan Transit in 1939–1940. The latter were the first rapid transit cars to use PCC technology developed for streetcars. Interchangeable parts would later make it possible for the CTA to reuse portions of scrapped PCC streetcars on 570 new rapid transit cars. (C. Edward Hedstrom photograph, author's collection.)

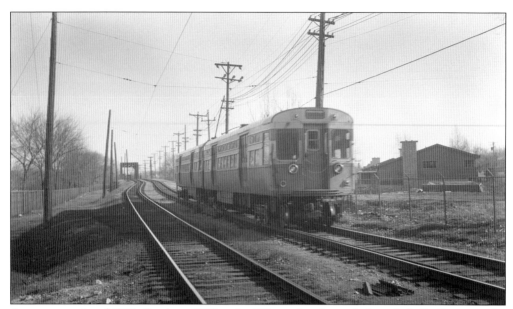

A two-car train of CTA flat-door 6000-series "L" cars heads south from Isabella Street in the 1950s toward the bridge over the North Shore Channel. By 1957, enough new rapid transit cars were on hand to allow for the retirement of the last of the wooden cars. Some had been in use for more than half a century.

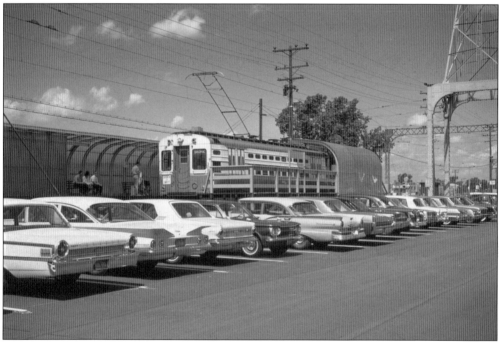

A year after the North Shore Line ceased operations in 1963, the CTA revived service on five miles of the former interurban as the *Skokie Swift*. Here is car 30 at the Dempster Street Terminal on August 11, 1964. This single-car unit, built in 1960 by St. Louis Car Company, is preserved at the Illinois Railway Museum. There is an interesting variety of 1960s cars in the parking lot, including a first-generation Corvair. (Douglas N. Brotjahn photograph, author's collection.)

Five

INTERURBANS UNDER WIRE

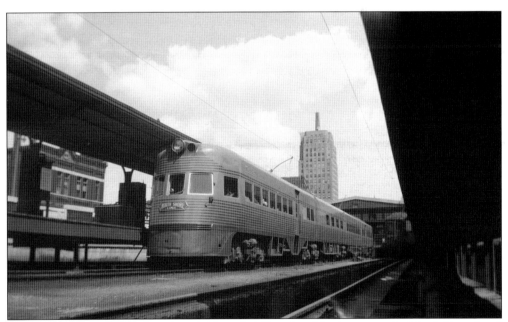

From 1941 to 1963, the Chicago, North Shore & Milwaukee (also known as the North Shore Line) had a pair of streamlined, articulated electric interurbans called "Electroliners." Here is one set at the Milwaukee terminal. South of Howard Street, the North Shore Line accessed downtown Chicago via the "L". In service, they had a limited top speed of 85 to 90 miles per hour but were capable of more. Their top speed had to be reduced to give crossing gates enough time to lower.

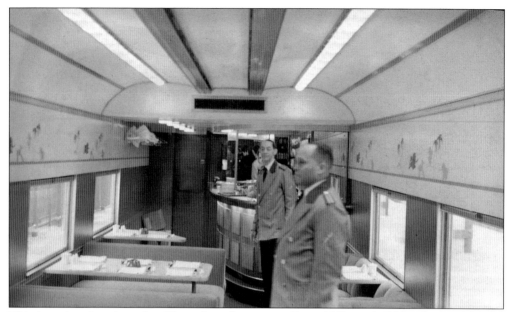

This is an interior view of an Electroliner lounge car. From 1941 until 1983, riders could order drinks and feast on "Electroburgers" while traveling between Chicago and Milwaukee. Interurban trains entered Chicago's Loop via the "L" system.

Between 1939 and 1942, the North Shore Line allowed the Central Electric Railfans' Association to use wooden car 300 as their club car. Behind it is North Shore city streetcar 313. Wooden cars were eventually replaced by steel cars. During World War II, car 300 was used by the North Shore Line as a locker room for female employees who were hired to fill manpower shortages. It was scrapped in 1947, as the railroad no longer wanted to use wooden cars, and parts had been removed from this car for use on some wooden cars that were sold to the Chicago, Aurora & Elgin.

North Shore Line cars 411 and 715 are pictured on the Shore Line Route in suburban Wilmette. Interestingly, both cars have survived. The 411 was originally built as a trailer observation car by Cincinnati Car Company in June 1923. Since 1989, it has been owned by the Escanaba & Lake Superior. The 715 was built by Cincinnati in 1926. It was acquired by the Fox River Trolley Museum in 1988.

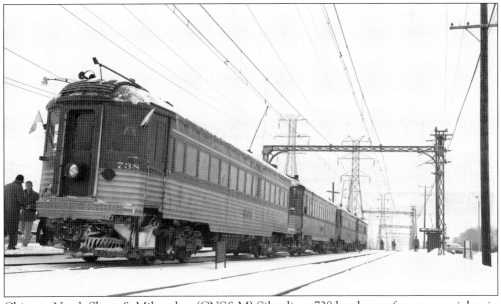

Chicago, North Shore & Milwaukee (CNS&M) Silverliner 738 heads up a four-car special train making a station stop at Northbrook during a snowstorm in February 1960. The North Shore Line has a very active fan base who fell in love with the railroad and have long lamented its passing. Service ended in the wee hours of January 21, 1963, in frigid subzero temperatures. (Richard H. Young photograph, author's collection.)

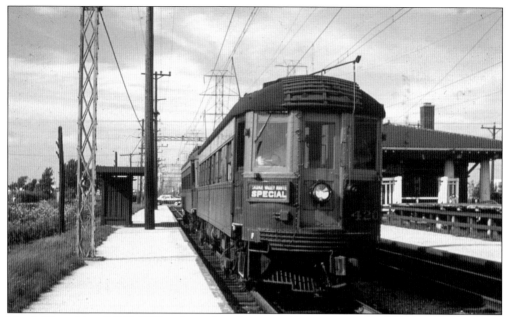

North Shore Line (NSL) 420 heads south at Dempster Street, the current end of the line for the CTA Yellow Line (the *Skokie Swift*), which revived a small portion of the old interurban a year after service ended in 1963. The 1920s Insull-era station has been saved but was relocated a short distance from here to allow space for buses to enter and exit.

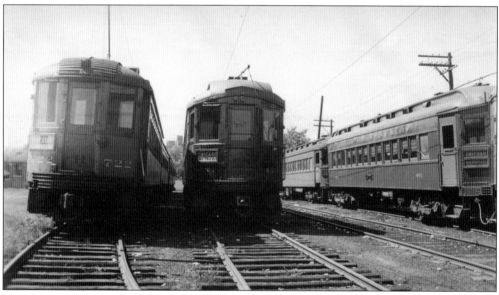

Here is a very rare view of the Laramie Avenue Yards on the Garfield Park "L" in 1936. At left is NSL car 722, heading up a four-car train and signed for Wheaton on the Chicago, Aurora & Elgin (CA&E). At right are CA&E cars 421 and 401. Car 722 was built by Cincinnati Car Company in 1926. Normally, the two interurbans did not operate on each other's tracks, but it was certainly possible, as both were configured to run on the Chicago "L" system. At one time, all three major Chicago interurbans, and the "L" system, were part of Samuel Insull's empire. (Edward Frank Jr. photograph, author's collection.)

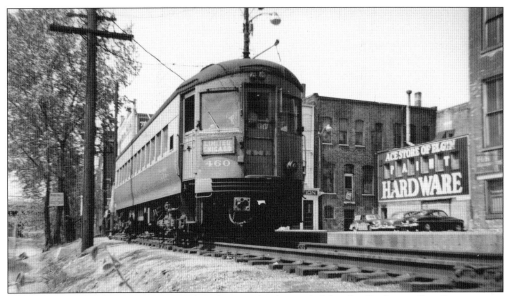

CA&E 460 in Elgin on May 14, 1953. This car, built in 1945 by the St. Louis Car Company, is preserved in operating condition at the Illinois Railway Museum. Some would say the 10 cars in this series (451–460) were the last standard interurban cars built in the United States, but as with many things, that is a debatable point. There are other contenders for the honor that are more modern in style.

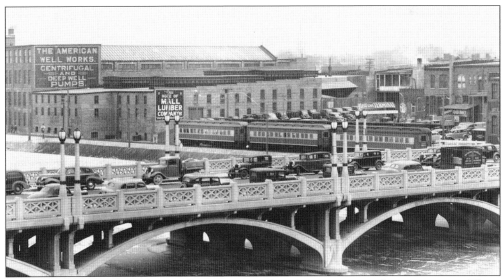

The Chicago, Aurora & Elgin's off-street terminal at Aurora is seen when it was new. There is a sign advertising the new terminal, which opened on December 31, 1939. This picture was probably taken in 1940. Previously, trains ran on city streets in downtown Aurora. The bridge in the foreground, which is still there, is New York Street. There is now a man-made island in the Fox River at this location, home of the Hollywood Casino Aurora, which opened in 1993.

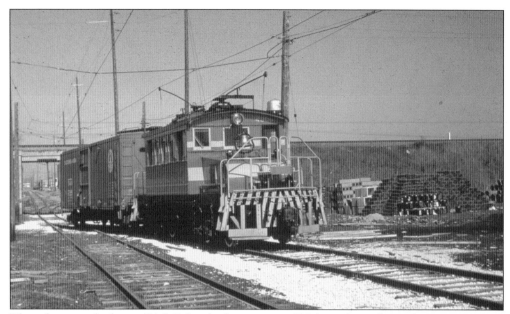

This photograph shows CA&E freight locomotive 4006 on the industrial Mount Carmel Branch. Unfortunately, neither the CA&E nor the North Shore Line had enough profitable freight business to sustain their money-losing passenger operations in a time before government subsidies were available.

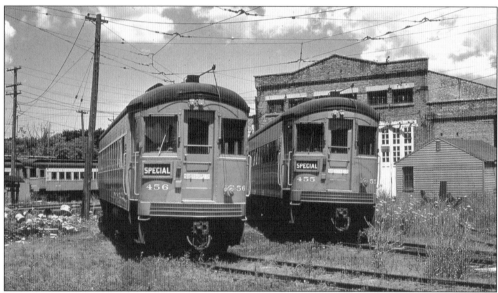

In the summer of 1959, CA&E cars 455 and 456 are on display at the Wheaton Shops, idle but waiting for prospective buyers. Passenger service had ended two years earlier. Of the 10 cars in this series, only four were saved. The two cars shown here were scrapped. The entire railroad could have been bought for just $6 million in 1956, but the problem was, no governmental body, whether state, county, or local, was willing to provide an operating subsidy to keep service going. For wont of a buyer, the railroad was abandoned in 1961 and scrapped. Fortunately, large portions of the right-of-way became the Illinois Prairie Path, a hiking and biking trail, one of the first such "rail to trail" conversions in this country.

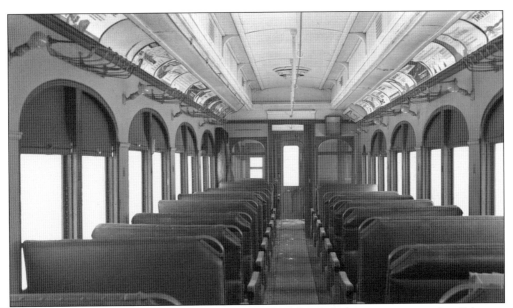

The interior of CA&E wooden car 300 is photographed shortly before it was scrapped on February 25, 1962. Unfortunately, no buyer came forward to save this car, despite the relatively good condition of its interior. The good news is several other CA&E cars were saved by museums, and many have since been restored.

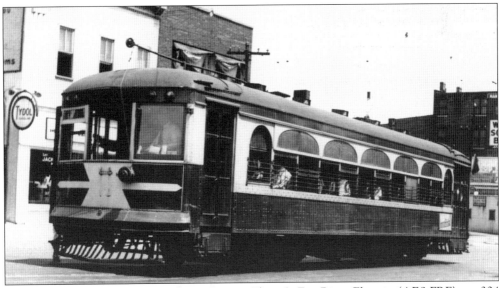

This is a rare photograph, as it shows Aurora, Elgin & Fox River Electric (AE&FRE) car 304 prior to the abandonment of passenger service in 1935. For a time, the AE&FRE was a subsidiary of the Aurora & Elgin and ran local streetcars, interurbans, and electric freight between those two cities. This car returned to its original rails in 2009, when it was purchased by the Fox River Trolley Museum, where it operates today. Between 1935 and 2009, the car was in Ohio, first on the Shaker Heights Rapid Transit line and then at Trolleyville USA, a local museum operation.

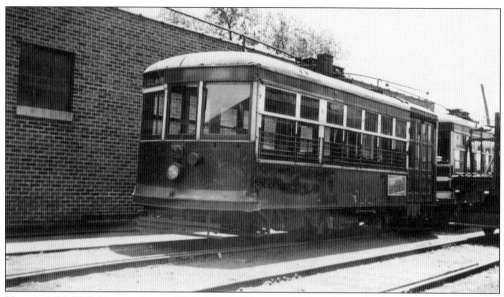

Here is AE&FRE Birney city car 72 in May 1934, a year before the end of passenger service. The caption reads "Color: Orange. 2 Motors. This system, which operated local cars in Aurora and Elgin, as well as an interurban line between those two cities, abandoned April 1, 1935." A small portion of the AE&FRE did survive in South Elgin as a freight line, which has now become trackage for the Fox River Trolley Museum. Birney cars were lighter weight, mainly had single trucks, and improved safety features. They were successful in many smaller cities, but not so much in Chicago. (Earl W. McLaughlin photograph, author's collection.)

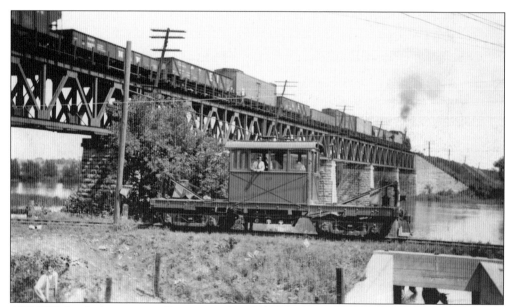

AE&FRE freight locomotive 49 is pictured at Coleman on September 2, 1940, with the Illinois Central overhead. This was one of the earlier CERA fantrips. By then, the line was freight-only, although still operating under trolley wire. (Roy Bruce photograph, author's collection.)

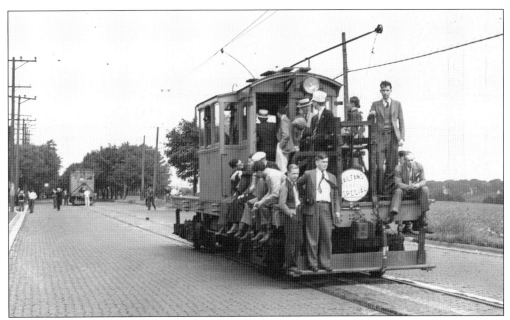

On September 2, 1940, fans ride AE&FRE locomotive 23 on a CERA fantrip. It would not be possible for fans to ride a train like this today, due to liability concerns. People did not think about such things back then—fans would climb on just about anything without regard to their personal safety. Fortunately, accidents were rare.

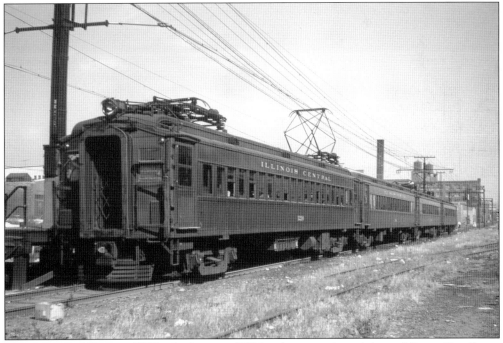

Illinois Central Electric (ICE) suburban car 1210 heads up a train arriving at Ninety-First Street on the South Chicago Branch on September 9, 1959. This car was built by Pullman in 1929. While not an interurban, per se, the ICE shared its trackage with the South Shore Line, which is very much an interurban. (Clark Frazier photograph, author's collection.)

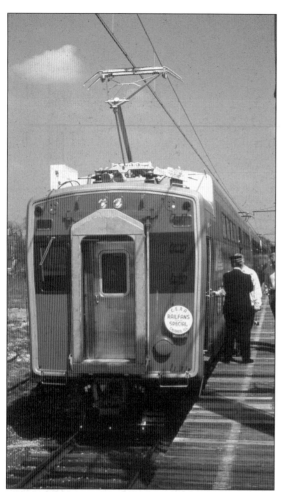

An ICE bi-level is pictured at Blue Island during a CERA fantrip on June 24, 1983. These were built by the St. Louis Car Company in 1971–1972 and replaced 1920s-era equipment. The original bi-levels, in turn, have been replaced by more modern equipment. (David Sadowski photograph.)

Chicago, South Shore, and South Bend cars 2 and 504 are at the Michigan City Station on August 30, 1960 (note the 1960 Ford at left). Passenger car 2 was built by Pullman in 1926, when the line was upgraded and began running to downtown Chicago over the Illinois Central Electric. Interurban freight trailer 504 came to the South Shore in 1941 by way of the Indiana Railroad and was generally used to haul newspapers. It was retired in 1975 and is now on display at the Illinois Railway Museum. The South Shore station building at right was last used in 1987 and is now owned by Michigan City. There are plans to preserve at least the facade. In 1960, as today, many South Shore trains terminated at Michigan City. The line now ends at the South Bend International Airport. (Meyer photograph, author's collection.)

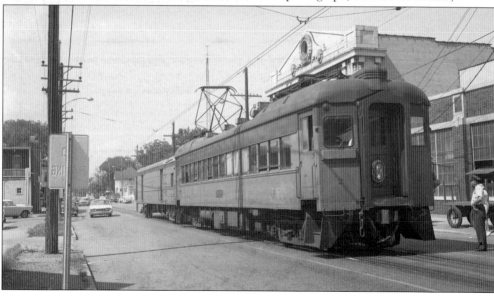

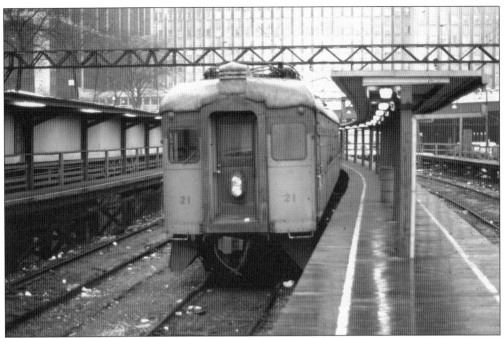

South Shore Line car 21 is pictured at the Randolph Street Terminal in the early 1980s, shortly before it was retired. Car 21 was built by Pullman in 1927, lengthened in 1946, and is now preserved by the East Troy Electric Railroad in Wisconsin for its museum operation. (David Sadowski photograph.)

In the 1970s, the South Shore Line began applying these charming decals to its aging train cars. Fortunately, this interurban did survive. New cars were purchased, many of the old ones were saved, and the South Shore Line's future now seems assured under the aegis of the Northern Indiana Commuter Transportation District (NICTD). There are plans to double-track the eastern portion of the line and build a new branch line extension to Dyer, Indiana.

In 1983, the original South Shore Line Insull-era cars were giving way to these shiny Nippon Sharyo Japanese-built replacements, which are still in service. A four-car train prepares to head south at Randolph Street in 1983. The terminal area has since been covered over by Millennium Park, home of the Cloud Gate sculpture, more commonly known as "The Bean." (David Sadowski photograph.)

This remarkable photograph was taken at the North Shore Line's Milwaukee terminal in January 1963, possibly on the 21st, the very last night of operation. If so, the temperature was well below zero. It was a dark and chilly end to what the late historian George W. Hilton called "The Interurban Era" in America.

Six

THE STREAMLINED ERA

In 1934, CSL 7001 heads north at State and Washington Streets. This experimental pre-PCC car brought visitors back and forth to A Century of Progress, the 1933–1934 Chicago World's Fair. Note that there are only three stars on the Chicago flag seen here. A fourth, symbolizing Fort Dearborn, was added in 1939. The other stars symbolize the Great Chicago Fire and two World's Fairs, the other being the 1893 Columbian Exposition. (CSL photograph, author's collection.)

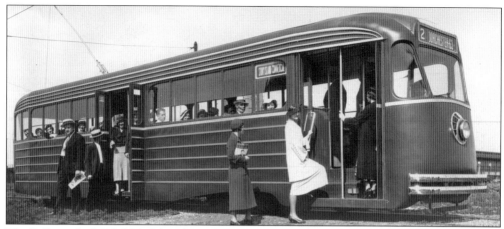

The Pullman-built PCC Model B, shown here at Navy Pier, is one of three experimental streetcars that ran in Chicago during 1934. Chicago was very much involved in the process that led to the development of the PCC streetcar two years later. (Chicago Architectural Photographing Company photograph, author's collection.)

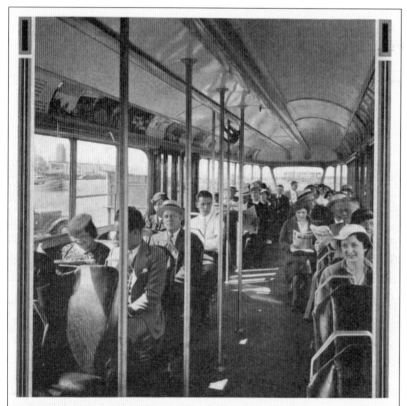

ATTRACTIVE INTERIOR ARRANGEMENTS OF "P. C. C." MODEL CAR BEING TESTED BY SURFACE LINES ENGINEERS

The interior of the PCC Model B is seen in the September 1934 issue of *Surface Service*, the CSL employee magazine. The bucket seats are not that much different than those on the 1929 Sedans.

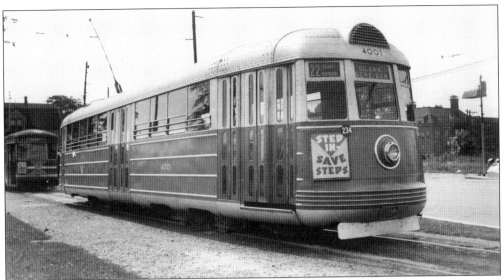

CSL 4001 on Route 22 (Clark Street–Wentworth Avenue) in the late 1930s. This experimental aluminum-bodied car was built by Pullman in 1934. Its body shell is now at the Illinois Railway Museum. As with the 7001, this car required a dedicated crew, as it was mechanically unique to the fleet. After the Surface Lines bought 83 PCC cars in 1936, there was less interest in keeping the experimental cars running, and they were last used in service around 1944.

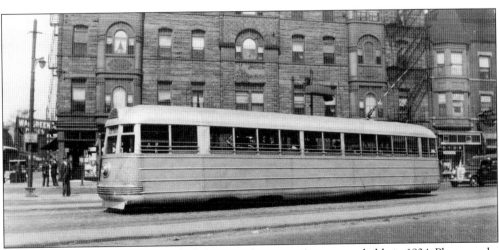

CSL 4001 is shown in service on Clark Street at Armitage Avenue, probably in 1934. Photographs like this are rare, since the 4001 was apparently not very reliable. Known as a "hangar queen," it was retired in the early 1940s, along with the more successful 7001.

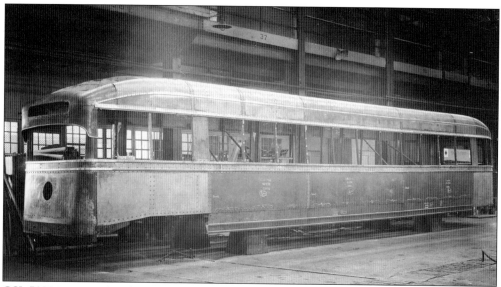

CSL 7001 is pictured under construction at the Brill plant in 1934. Of the three such cars tested by CSL, this one was most like the PCC that emerged in 1936. As it turned out, J.G. Brill, which had been up until this time the leading American streetcar builder, never actually built a PCC car. The company had a policy not to pay patent royalties to other firms and withdrew from the PCC project after building cars similar to the 7001 for the Washington, DC, system in 1935. The Brilliner, Brill's answer to the PCC, came a few years later but was not successful in the marketplace. Brill built its last streetcar in 1941.

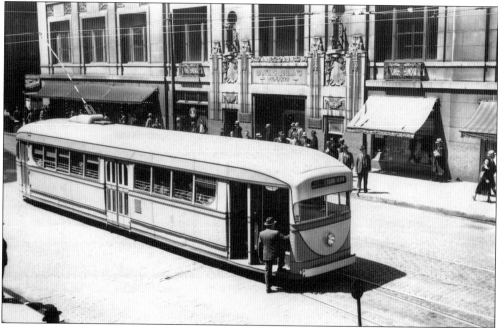

CSL 7001 is pictured on Route 22 at Clark and Adams Streets. The Banker's Building, at rear, is now known as the Clark-Adams and is at 105 West Adams Street. At 476 feet tall, it is the tallest building ever in Chicago to be clad entirely in brick. It was built in 1927, and this photograph was probably taken in the 1930s.

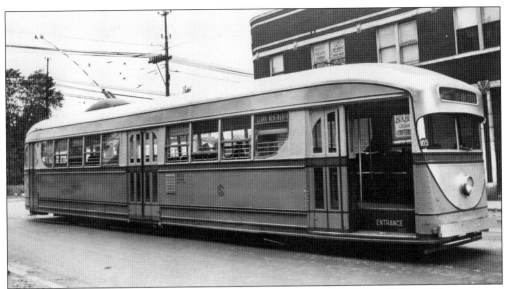

Here is a rare shot of CSL experimental pre-PCC 7001 at Eighty-First and Halsted Streets, most likely in the 1930s. This was the south end of the busy Clark Street–Wentworth Avenue line, which, strangely enough, never had a turnback loop at this location. Until the end of service in 1958, trolleys had to back up into traffic to turn around, an awkward arrangement.

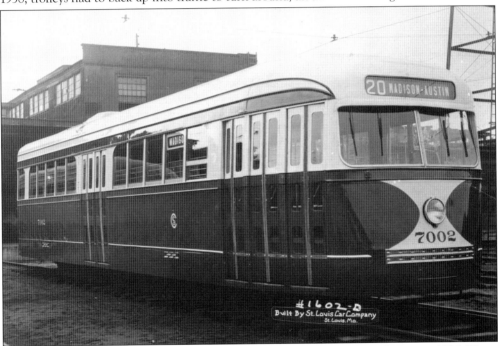

A builder's photograph shows CSL 7002, the first PCC car delivered to Chicago in 1936. These were put into service on Madison Street for several reasons. This line spanned the entire width of the city from end to end, included some downtown trackage, and had a branch line. CSL thought this would be a good test of the PCC's capabilities. As it turned out, even the speedy PCCs were significantly delayed by Loop traffic congestion, which could have been alleviated by a streetcar subway. (St. Louis Car Company photograph, author's collection.)

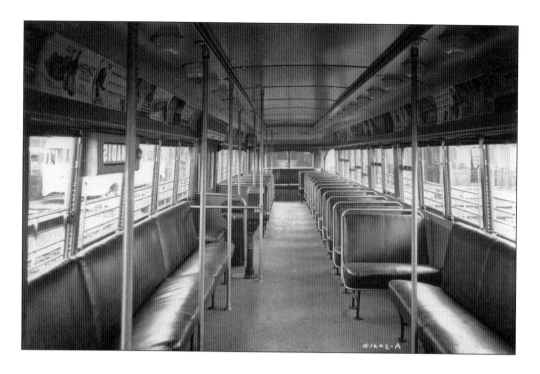

These photographs show the modern and comfortable interior of PCC 7002, which was fast, reliable, and quiet compared to older cars and had an improved heating and ventilation system. (Both, St. Louis Car Company photographs, author's collection.)

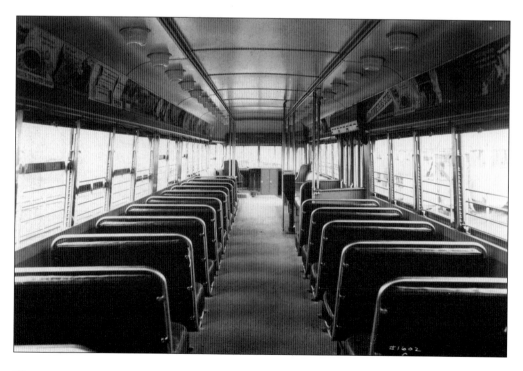

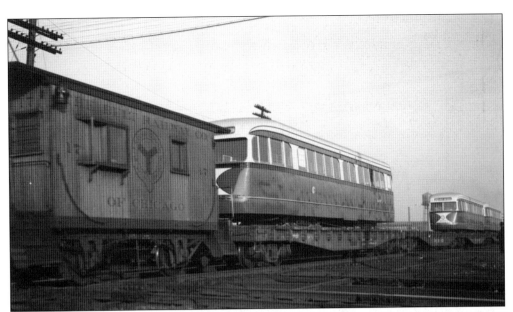

CSL prewar PCCs 4037 and 4036 are being delivered via the Belt Railway of Chicago on December 24, 1936. When these new PCCs were first introduced, thousands thronged to see the beautiful new trolleys. (Mike Raia Collection.)

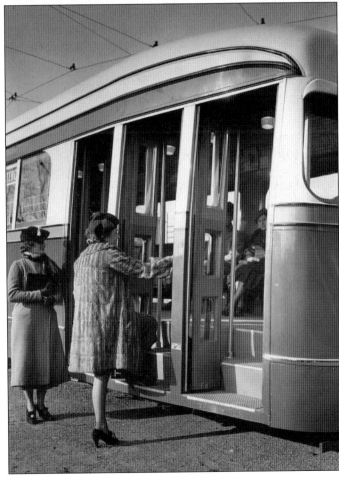

In this posed press photograph, probably taken in late 1936, two well-dressed models show how easy it is to get on the new streamliners. This may be car 7002. In the 1930s, having a fur coat was a status symbol for many women. Fans called the cars "Blue Geese," but there is no evidence this term was used before 1958. At least one contemporary reporter called them "Blue Devils," a name often applied to things that were fast. (Chicago Architectural Photographing Company photograph, author's collection.)

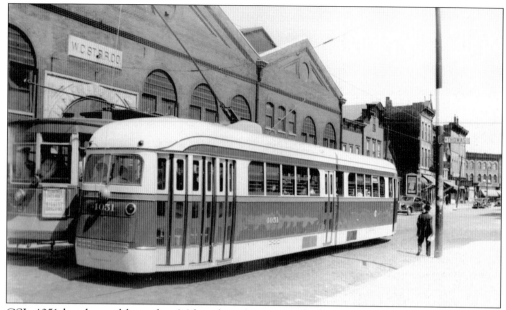

CSL 4051 heads southbound at Milwaukee Avenue and Thomas Street during a 1940–1941 experiment that determined the door configuration chosen for Chicago's postwar PCC cars. Note the West Chicago Street Railway Company building at left. Perhaps the photographer wanted to contrast the old with the new. (Edward Frank Jr. photograph, author's collection.)

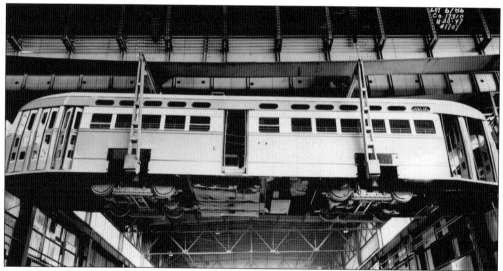

PCC 4306, under construction at the Pullman plant in Worchester, Massachusetts, was delivered to CTA on November 29, 1947. The main difference between this and the prewar cars was the addition of "standee" windows, which gave standing passengers a better view. The new cars were also slightly wider than their earlier counterparts. CSL called them "Surface Liners," but they were soon nicknamed "Green Hornets." (Pullman photograph, author's collection.)

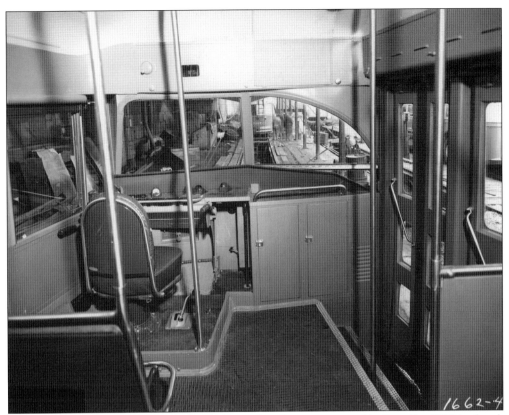

The interior of a PCC is seen on the St. Louis Car Company assembly line. Car 7227 is ahead, which means this is either 7226 or 7228. All three were delivered to CTA on March 29, 1948. Just four years later, the last PCC car built in America would roll off the assembly line. The rapid abandonment of streetcars in many cities put so many PCCs onto the used market that it depressed the market for new American trolleys for the next 20 years. Streetcars have since made quite a comeback.

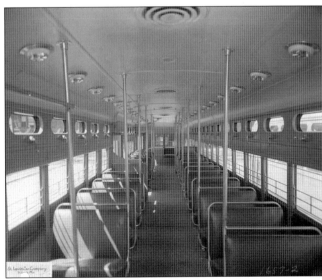

A St. Louis Car Company photograph of 7062's interior shows some differences in design and construction between this and the Pullman product seen on the next page.

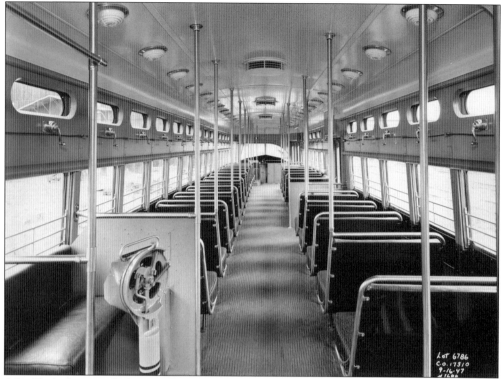

A builder's photograph shows Pullman PCC 4172's interior. Chicago had to split the order for 600 cars between two builders, as it was simply too much for any one firm to produce in a reasonable time. As it was, Pullman built 310 of the cars, while the St. Louis Car Company made 290. The CTA thought the St. Louis–built cars more successful in service, possibly because they were lighter and therefore used less electricity. The Pullmans were thought to have better overall construction.

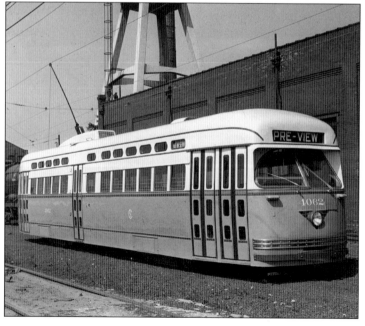

A CSL photograph shows brand-new 4062, the first postwar car delivered. It went into preview service in the Loop for a few days in September 1946. The new cars were quickly nicknamed "Green Hornets," due to the sound they made and their speed. This was inspired in part by the popular *Green Hornet* radio program, which was in turn a spinoff from *The Lone Ranger*. On the first few cars delivered, the "standee windows" area was painted white.

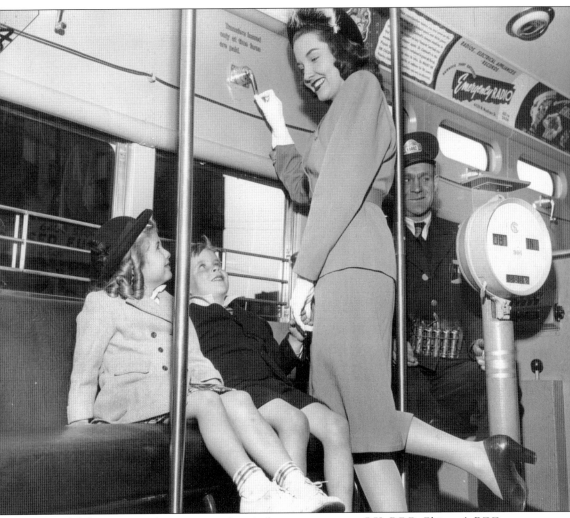

A model demonstrates how to open the windows on a postwar CSL PCC. Chicago's PCCs were all designed to be two-man cars, and the conductor's station can be seen to the right of the model. Passengers would enter through the rear door via a large vestibule. The car could then get going while the conductor collected fares. Passengers would leave via the center or front doors.

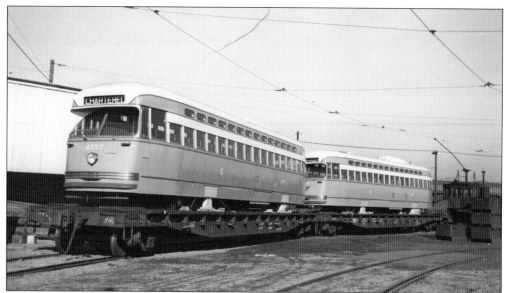

Cars 4157 and 4156 were delivered to South Shops on January 18, 1947, according to CSL records. (Joe L. Diaz photograph, author's collection.)

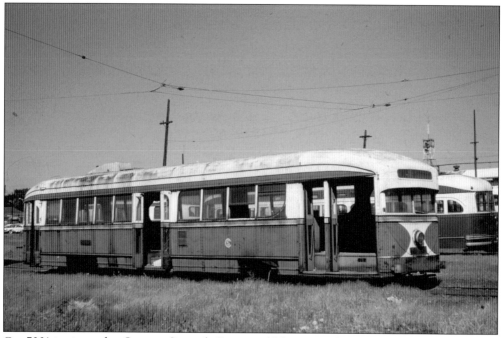

Car 7001 is pictured at Seventy-Seventh Street and Vincennes Avenue on September 10, 1959, shortly before it was scrapped. It is a shame that this groundbreaking car was not saved. Washington, DC, Transit car 1053, a similar pre-PCC built in 1935, was preserved for many years at the National Capital Trolley Museum in Maryland but was destroyed by fire in 2003. (Clark Frazier photograph, author's collection.)

Seven

THE WAR YEARS

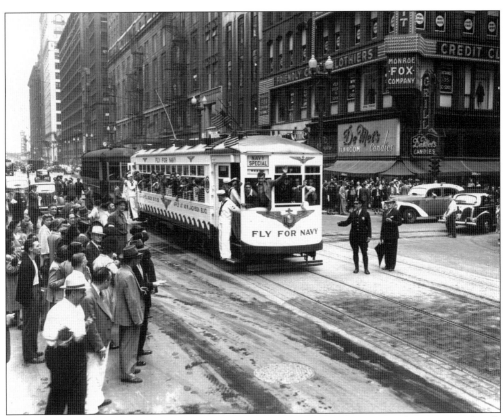

CSL 1775, decorated with "Fly for Navy" in September 1942, carries Navy volunteers as it heads south on State Street at Monroe Street. Decorated transit vehicles are more common today but were quite unusual during World War II. The year 1775 was when the first battles of the Revolutionary War were fought at Lexington and Concord, Massachusetts.

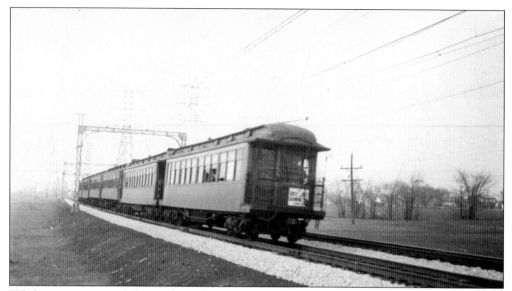

While patronage was light on the Niles Center Branch of the "L" (shown here), Chicago rapid transit cars performed yeoman service during World War II, transporting servicemen via the North Shore Line. Here is one such train, signed for Naval Station Great Lakes. One quarter of all Navy personnel during the war were trained there.

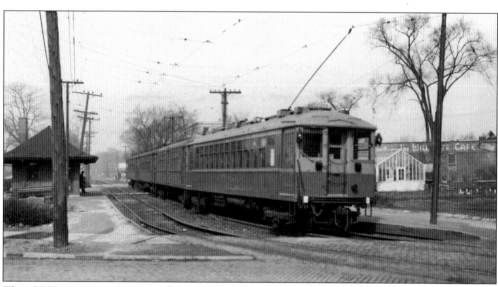

This CRT train is a wartime military special, running north over the North Shore Line at the Wilmette Avenue Station. This train has just come off one mile of slow "street running" on Greenleaf Avenue, which can be seen in the next picture. This section of the North Shore Line was known as the Shore Line Route, and service here ended on July 25, 1955.

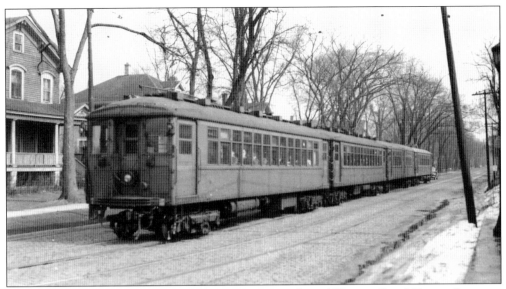

Those 4000s sure got around in their day. Here is a rare shot of Chicago Rapid Transit Company "L" car 4432 heading up a train in North Shore Line territory on Greenleaf Avenue in Wilmette, pressed into service hauling the military during World War II. This section of the route is a reminder that the North Shore Line began as several unrelated local streetcar lines that were gradually merged together. Some sections were updated, while others such as this remained unchanged until abandonment. Service here, on the Shore Line Route, ended on July 25, 1955.

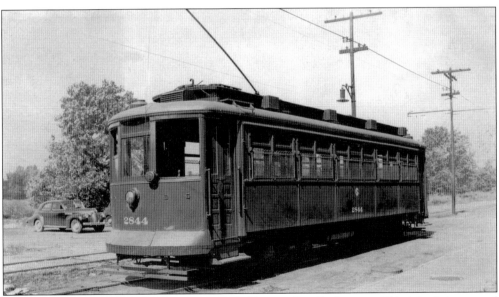

CSL 2844 was built by Jewett in 1903 as South Chicago City Railway car 324. After being stored for a decade, it was rehabilitated in October 1942 with an eye toward putting it back in service. Ultimately, though, it was deemed unsuitable even for one-man service on lighter lines and was converted into a salt spreader for use in the winter. This photograph may date to that late 1942 period, when 2844 was briefly put back into service.

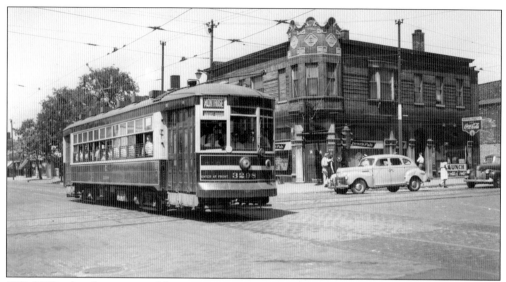

CSL 3298 is heading east on Montrose Avenue at Clark Street during World War II. There are service personnel in the background. The Surface Lines let military personnel ride free for the duration except during rush hours. Trolley buses were introduced on Montrose Avenue west of Milwaukee Avenue in 1931, and the entire line was converted to electric buses in 1948. Trolley bus service continued until 1973.

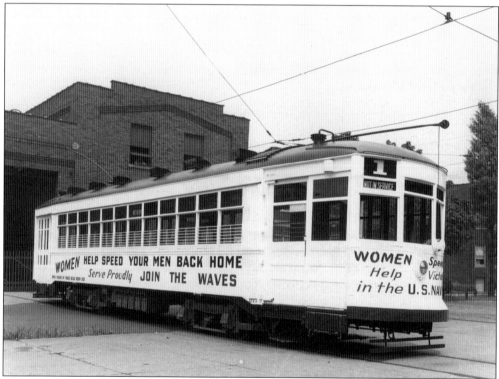

CSL 1775 is pictured in yet another patriotic paint scheme, this time supporting the WAVES (Women Accepted for Volunteer Emergency Service) at West Shops in October 1943. (CSL photograph, author's collection.)

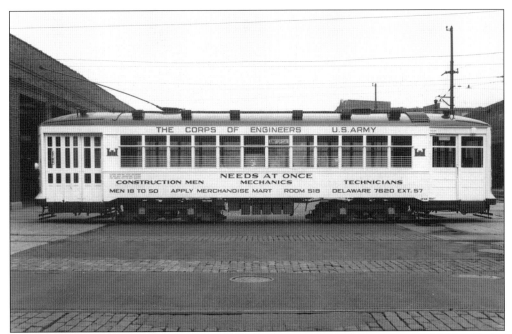

CSL 1740 promotes the Army Corps of Engineers at West Shops. During World War II, the Army Corps of Engineers built countless bridges, cleared minefields, and kept roads open in the European theater while clearing jungles and preparing for advances in the Pacific. (CSL photograph, author's collection.)

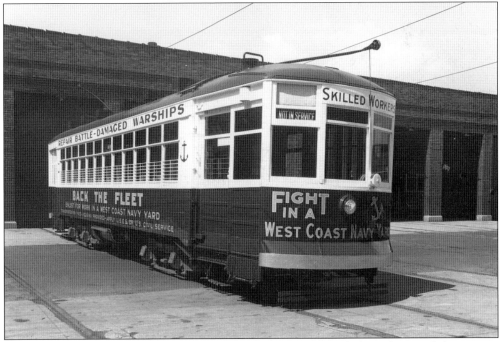

CSL 1740, in different patriotic garb, is at West Shops. Damaged ships that needed repair on the West Coast included some that were at Pearl Harbor on December 7, 1941, a day that Pres. Franklin D. Roosevelt predicted would "live in infamy." (CSL photograph, author's collection.)

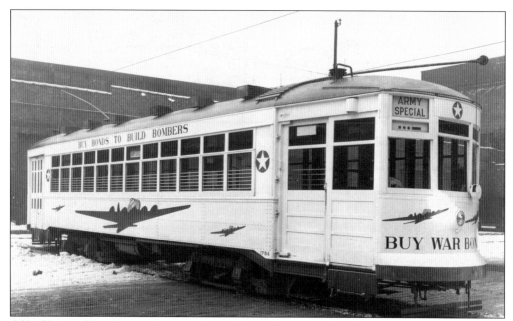

CSL 1784 is at West Shops selling war bonds. Many Chicagoans bought war bonds, helping to build thousands of bombers, some of which were built in Chicago. Approximately 17,000 Chicagoans were employed during the war at a huge plant on the Southwest Side that has since become the site of the Ford City Mall. In March 1943, students at one Chicago high school raised $300,000 to pay for a B-17 bomber, which was then named *Lane Tech of Chicago*, the only American bomber paid for by high school students. Its name later changed to the *Wacky Woody*, it was shot down by the Nazis near the Dutch town of Emmeloord on April 8, 1944. All 10 crew members survived the crash, although five were captured as prisoners of war. (CSL photograph, author's collection.)

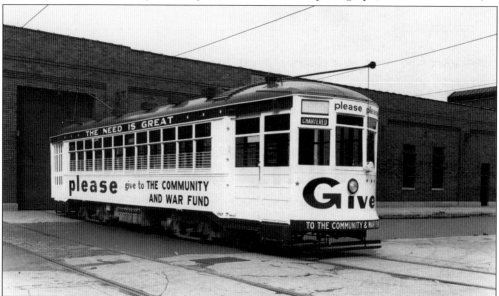

CSL 1727, at West Shops around 1944, is again supporting the Community and War Fund. Pamphlets for this fund implored Americans to "SHOW YOU CARE . . . Give your share! For our men in uniform, for our fighting allies, for welfare at home." (CSL photograph, author's collection.)

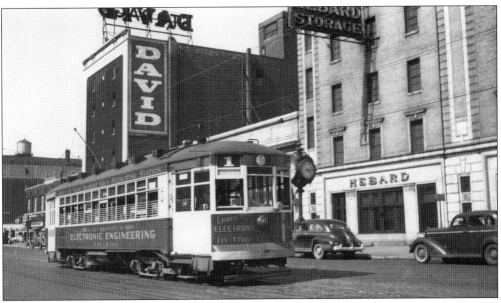

CSL 1776 promotes Electronic Engineering during World War II on Broadway just south of Devon Avenue. By the end of the war, CSL had decorated 21 different trolleys as "rolling billboards," some more than once. (Railway Negative Exchange photograph, author's collection.)

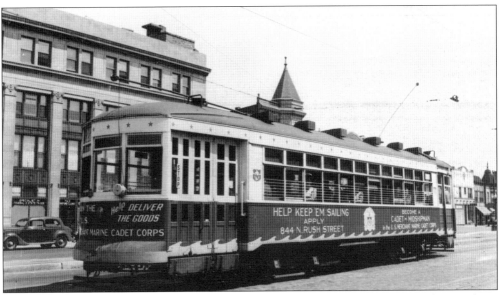

CSL 1775 is northbound on Clark Street at Devon Avenue, this time promoting the Merchant Marine. Folksinger Woody Guthrie was a member of the Merchant Marine during World War II. It was a dangerous duty, as many such ships were sunk by German U-Boats in the Atlantic. (Railway Negative Exchange photograph, author's collection.)

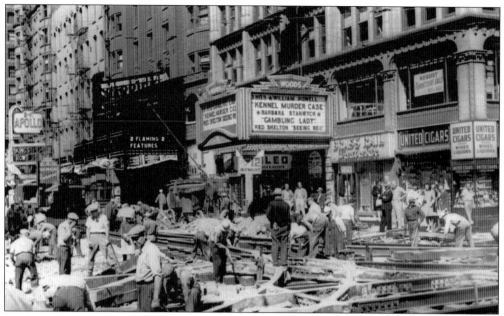

It is late August 1942, and tracks on Randolph Street at Dearborn Street are being put back into place, following subway construction on Dearborn. This subway was 80 percent completed when work stopped in 1942 due to materials shortages related to the war. Service in Chicago's second subway did not begin until February 1951. Three long-gone movie theaters are visible. From left to right are the Apollo, which is showing *King's Row*, arguably future president Ronald Reagan's best film; the Garrick, touting "two flaming features"; and the Woods, with a double bill from the 1930s. When the Garrick was demolished in 1961, the late Richard Nickel helped start a local preservation movement that eventually saved other historic structures. A theatrical tradition continues, as the Woods site is now occupied by the world-famous Goodman Theatre.

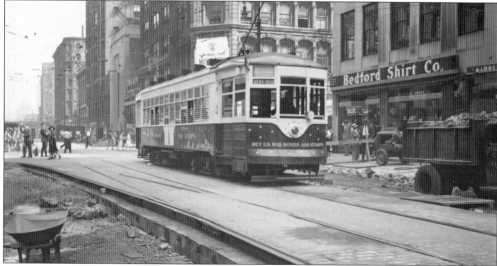

CSL 1731 is northbound on Dearborn Street at Washington Street in 1942. Note how the street has been resurfaced following construction of the Dearborn Street Subway, which did not open until 1951. It was 80 percent finished when construction was halted due to wartime materials shortages. The nearby State Street Subway was completed and opened on October 17, 1943.

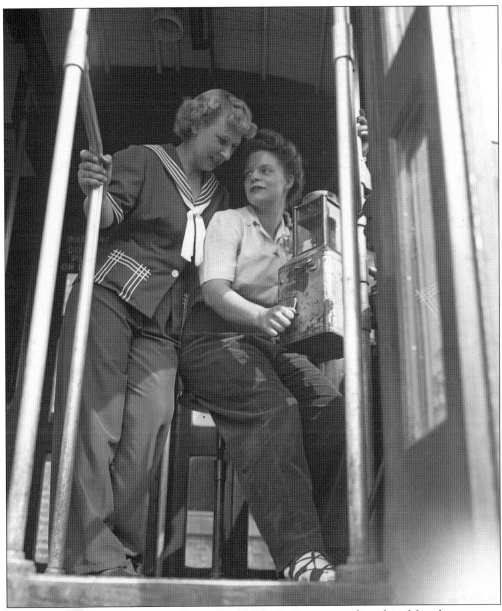

Faced with a manpower shortage during World War II, some transit lines hired female operators, although the Chicago Surface Lines did not. Here, Cleo Rigby (left) and Katherine Tuttle are training in North Chicago on June 25, 1943, for the North Shore Line's city streetcar operations, which were mainly in Waukegan. A photograph of the type of streetcar they operated is featured on page 93.

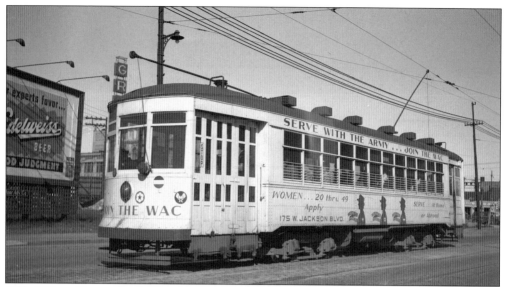

CSL 1751, at Devon Avenue and Broadway, asks women to join the WAC (Women's Army Corps). It was originally created as the Women's Army Auxiliary Corps in 1942. It was disbanded in 1978.

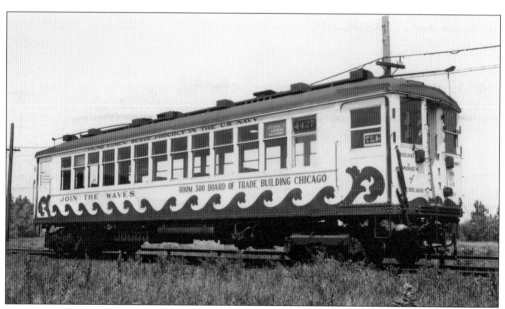

During World War II, Chicago Rapid Transit car 4427 was done up in patriotic garb to support the WAVES (Women Accepted for Volunteer Emergency Service). It is signed as a Jackson Park Express via the subway, so this probably dates the picture to 1943–1944. (Joe L. Diaz photograph, author's collection.)

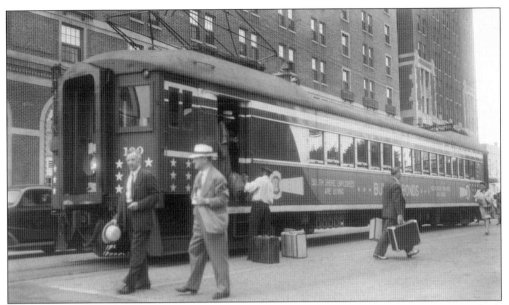

South Shore Line car 100, originally built by Pullman in 1926, was lengthened in 1943, which is probably when it was repainted in the patriotic war bond livery seen here. Passengers are disembarking at LaSalle and Michigan Streets in South Bend, which served as the interurban's eastern terminal until 1970, when service was cut back to the outskirts of town. The old LaSalle Hotel is at left. Note that many people have brought luggage. Tires and gasoline were rationed during the war, and public transit was often the only way to get around. (Seaver photograph, author's collection.)

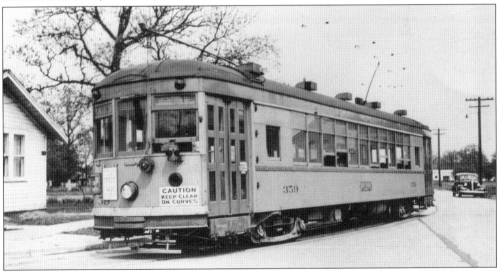

North Shore Line city streetcar 359 is shown in service in Waukegan on May 20, 1945. The war in Europe had recently ended, but fighting was still going on in the Pacific. These streetcars served the nearby Great Lakes Naval Base, today the Navy's only boot camp, which provided a lot of traffic. The women shown on page 91 would have operated streetcars like this. Car 359 was built by the St. Louis Car Company in 1928 and gave faithful service in Waukegan until 1947, when streetcars were abandoned. It was then sent to Milwaukee, where the North Shore had a similar service that quit in 1951. Today, sister car 354 is preserved at the Illinois Railway Museum.

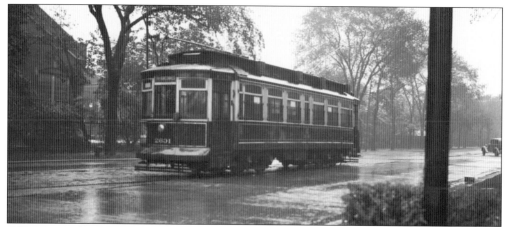

CSL 2601 is shown running on September 22, 1945, the last day of streetcar service on Route 111 (111th Street) west of Indiana Avenue. Car 2601 was built by the St. Louis Car Company in 1901 and is known as a "Robertson Rebuild." With new buses and streetcars on order, the days of these older cars were numbered.

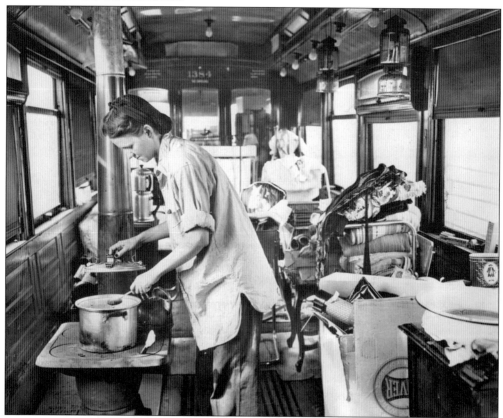

Returning GIs faced a housing shortage. In April 1946, Edith Sands prepares dinner on the small stove in the Chicago streetcar where she and her husband, Arthur, and their five-month-old son, Jimmy, had recently moved. The body of CSL trolley car 1384, built in 1906, was purchased by the Sands family at a public sale and propped up on a five-acre site near Chicago's southern edge. The car was lighted by gasoline lamps. (Acme Press photograph, author's collection.)

Eight

UNIFICATION AND CHANGE

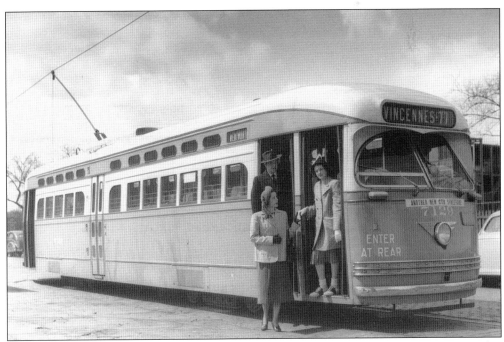

CTA 7129, delivered on January 20, 1948, is labelled as "Another New CTA Streetcar." This picture has the appearance of a posed shot. The woman at right is apparently a "Bobby Soxer," many of whom were fans of up-and-coming singer Frank Sinatra. (Krambles-Peterson Archive.)

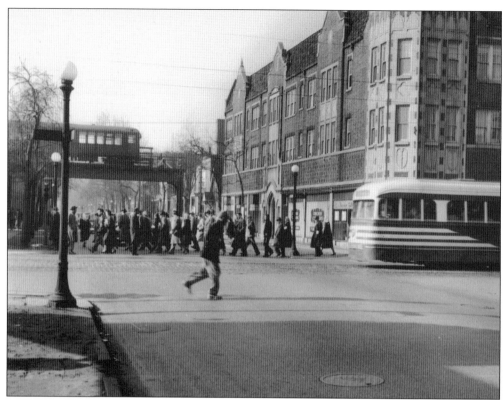

One reason for the creation of the CTA was to coordinate the surface and rapid transit systems so they would work better together. For many years, the Englewood "L" ended rather inconveniently at Sixty-Third Street and Loomis Boulevard. Here, people are exiting an eastbound Sixty-Third Street PCC to change trains for an "L" ride downtown. In 1969, the terminal was sensibly extended a couple blocks west to Ashland Avenue, a more logical transfer point.

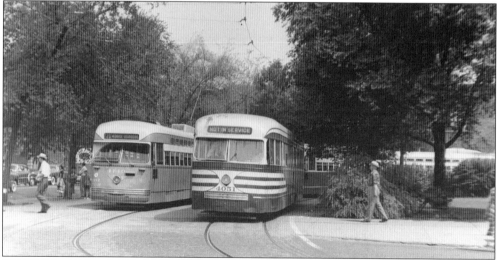

CTA PCCs 4140 and 4051 contrast the postwar and prewar car designs in this July 1951 scene at the Madison Street–Austin Boulevard loop. The prewar car at right is in "tiger stripes," meant to alert drivers that these cars were wider than they might appear.

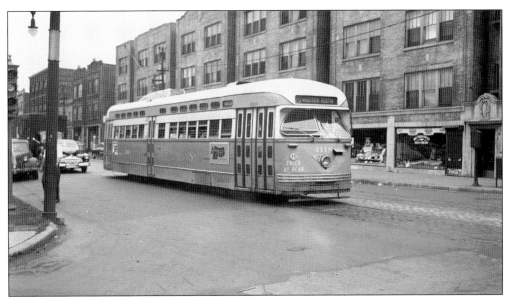

CTA 4118 is westbound on Madison Street at Central Park Boulevard, across from Garfield Park, looking southeast, around 1950–1951. There is a 1948 Buick behind the PCC. Many buildings in this neighborhood were destroyed in April 1968 when fires broke out from rioting following the assassination of Dr. Martin Luther King Jr.

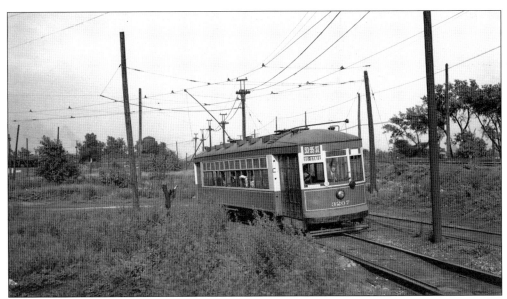

CTA 3207 is signed for the Ninety-Third Street–Ninety-Fifth Street route on June 27, 1948. This was early in the CTA era, and red streetcars such as this faced a very uncertain future. The Rock Island Railroad is at right. This view faces east at about Ninety-Fourth Place, a block west of Stony Island Avenue.

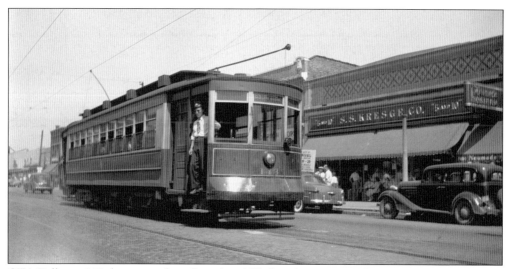

CTA Pullman 143 changes ends at Grand and Harlem Avenues in July 1949. It appears that the motorman is just about ready to head east and switch over to the other track. This was one of the busiest shopping districts in the entire city, with three dime stores: a Neisner's, Woolworth's and an S.S. Kresge. The rapid development of the Mont Clare neighborhood and adjoining Elmwood Park came after the Grand Avenue route was extended to Harlem Avenue around 1911. (C. Edward Hedstrom photograph, author's collection.)

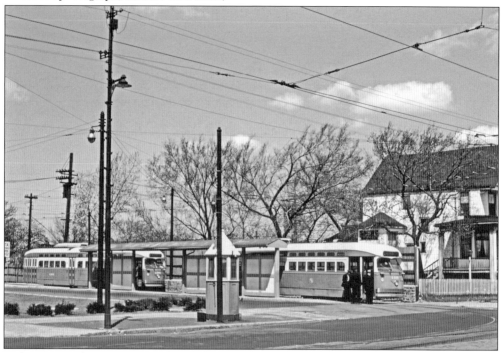

CTA 4409 and 4390 are pictured at the beautifully landscaped turnaround loop at Western Avenue and Berwyn Avenue on May 13, 1950. The PCCs needed loops because they were single-ended cars. Off-street loops were safer and more convenient for riders and did not interfere with street traffic. By the end of the 1950s, the CTA had more than 100 in use. (John D. Koschwanez photograph, John F. Bromley Collection.)

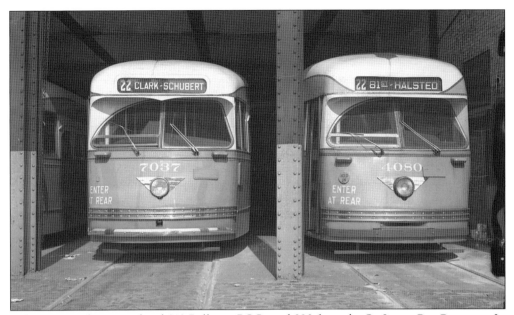

In late 1945, Chicago ordered 310 Pullman PCCs and 290 from the St. Louis Car Company. In this June 22, 1947, view at the Seventy-Seventh Street Station (carbarn), one can appreciate the subtle differences in styling between the curvy St. Louis product on the left and the boxier Pullman on the right. If this photograph had been taken at Devon Station, the northern end of the line, the support posts pictured would have been made of wood, not steel.

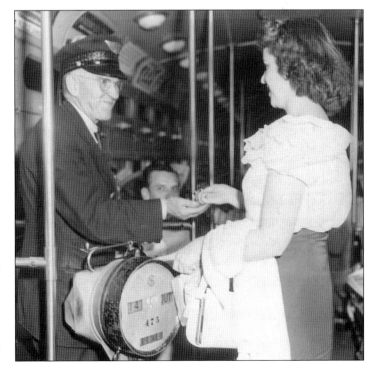

On August 1, 1951, CTA surface system fares were increased to 17¢. Here, on two-man PCC 4188, Elma Parrssinen dutifully pays her fare to conductor James Long. During CTA's first decade, surface system ridership dropped by about half. Increased auto registrations are usually blamed, but frequent fare increases were also a factor. The CTA did not have any taxing authority and had to make a go of it via the fare box. It is remarkable it succeeded for as long as it did without government subsidies. (Acme Press photograph, author's collection.)

On May 25, 1950, CTA PCC 7078 derailed when it split a switch and crashed headlong into a gasoline truck at State Street and Sixty-Second Place. This set off a conflagration in which many people were trapped inside the streetcar; 33 people were killed and 50 injured.

The fateful accident destroyed several nearby buildings. A switch was set to divert streetcars to the left, but the PCC went through it at a high rate of speed. Historians are still debating what went wrong, but due to the crash, CTA vehicles were later equipped with levers for opening doors manually in an emergency.

Here is 14-year-old Beverly Clark, one of the fortunate survivors of the "Green Hornet Streetcar Disaster." She was thrown to the floor by the collision but managed to escape with relatively minor injuries. News reports indicated that 44 people on the car survived. (Acme Press photograph, author's collection.)

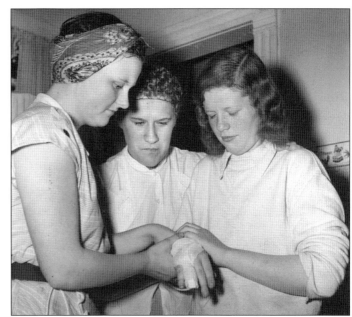

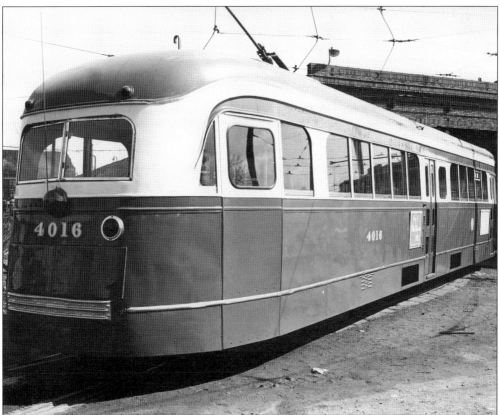

Prewar PCC 4016 was the first car converted to one-man operation in 1951. The rear door here is completely blocked off, but the City of Chicago soon insisted on the addition of an emergency exit, for which the agency publicly thanked the city. (CTA photograph.)

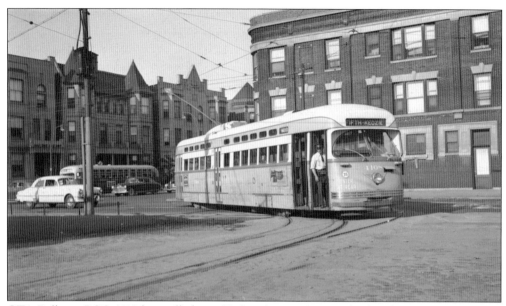

CTA Pullman PCC 4108 has pulled into Kedzie Avenue Station (carbarn) around 1951. In the background, a Chicago Motor Coach Route 26 bus heads east on Jackson Boulevard. The privately owned CMC competed against the CTA. On October 1, 1952, CTA purchased CMC's assets and routes. CMC operations were gradually absorbed into CTA's, and Route 26 became today's 126. (Robert Selle photograph, Wien-Criss Archive.)

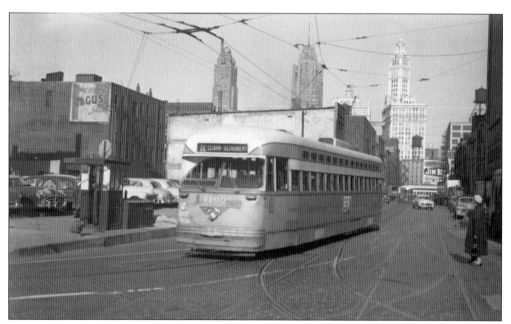

CTA PCC 4100, built by Pullman, is turning from Kinzie Street onto Clark Street in November 1953, with Tribune Tower and the Wrigley Building at the rear. Note the trolley bus wire, used to short-turn Route 65–Grand Avenue, which normally ran to Navy Pier.

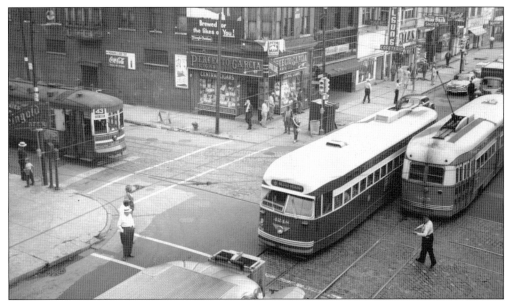

CTA 4248 is heading north on Halsted Street at Root Street in this view from July 21, 1952. Both major political parties held their conventions at the International Amphitheatre that year. The Democrats met from July 21 to 26 and nominated Gov. Adlai Stevenson. The Republicans were there from July 7 to 11 and nominated Gen. Dwight D. Eisenhower, who became the next president. (Thomas H. Desnoyers photograph, Krambles-Peterson Archive.)

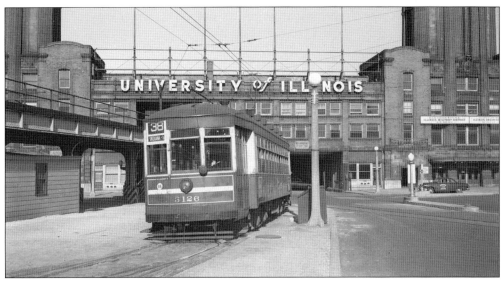

One-man car 3126 is at Grand Avenue and Navy Pier in October 1949. This was the temporary home of the University of Illinois from 1945 to 1965, until completion of the Chicago Circle campus, which was named after an expressway interchange. Both the college and interchange have since been renamed.

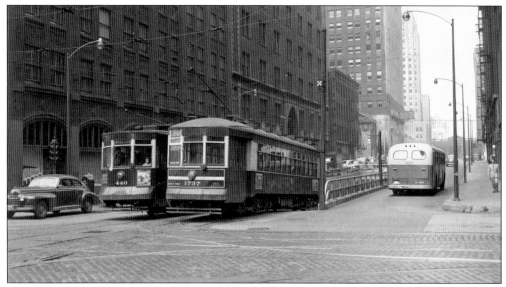

CTA cars 440 and 1737 are entering and leaving the Washington Street tunnel that will take them under the Chicago River, while CMC bus 622 is nearby. These river tunnels could have been expanded into streetcar subways. (Richard W. Tesch photograph, Wien-Criss Archive.)

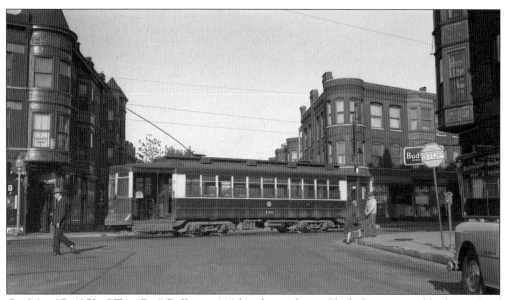

On May 27, 1953, CTA "Big" Pullman 144 heads south on Clark Street, one block north of Belmont Avenue. The photographer notes, "Headed south for North Limits Barn from Ashland line." Limits was located at 2684 North Clark Street, which was the city limits when first built for cable car use in the late 1800s. (Robert Selle photograph, Wien-Criss Archive.)

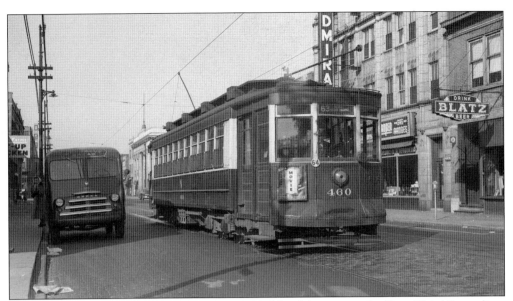

CTA "Big" Pullman 460 heads east, just east of Ashland Avenue on the Sixty-Third Street line, on October 11, 1952. This car is now at the Illinois Railway Museum. (Robert Selle photograph, Wien-Criss Archive.)

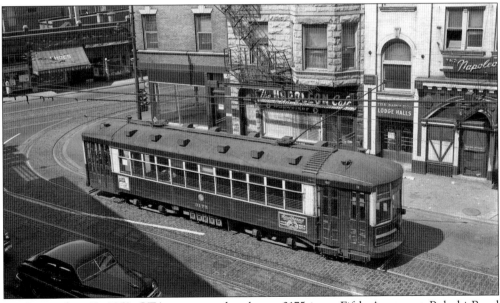

On September 13, 1953, CTA one-man shuttle car 3175 is on Fifth Avenue at Pulaski Road (formerly Crawford Avenue), the west end of the Fifth Avenue line. This had been a branch line from Route 20–Madison Street. From this point, the cars looped via Pulaski Road and Harrison Street before going back northeast on Fifth Avenue. The photographer was on the old Garfield Park "L" at Pulaski Road. Fifth Avenue began life as part of an early Indian trail. (Robert Selle photograph, author's collection.)

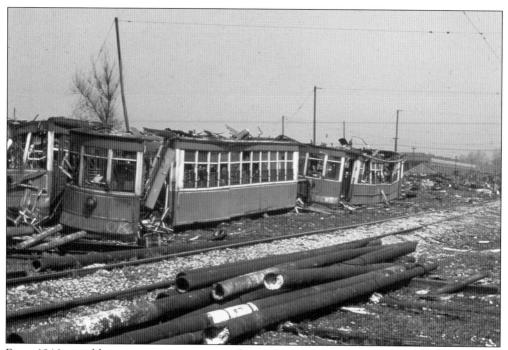

From 1946 on, older streetcars were scrapped on a continuous basis until, after the end of red car service in May 1954, there were only a handful of older cars remaining. By the time fans had begun to organize trolley museums, most of the older cars had already been destroyed.

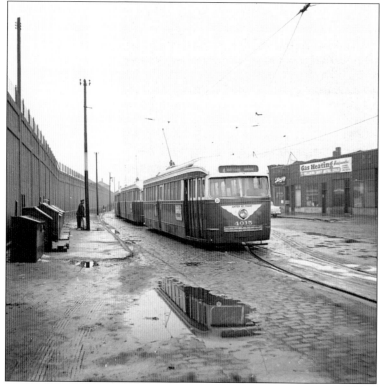

CTA 4015 rests at Cottage Grove Avenue and 115th Street, the south end of Route 4. Prewar PCCs ran here from 1952 to 1955, and Illinois Central Electric suburban trains ran on the embankment at left. Metra Electric trains continue to do so today.

This picture was taken on February 22, 1950, looking south on State Street at Lake Street from the "L". The PCC is on Route 36 (Broadway–State Street), while the Sedan is on Route 4–Cottage Grove Avenue.

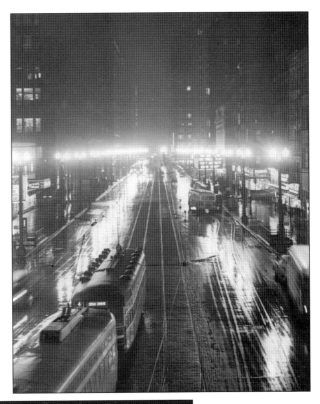

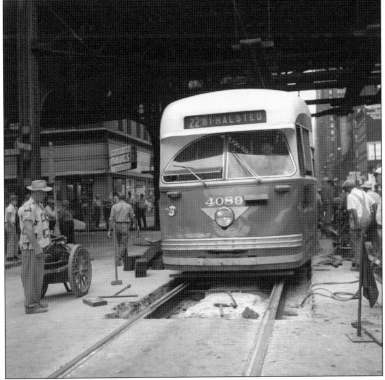

On a warm July 17, 1954, PCC 4089 moves through a work area heading south on Clark Street at Van Buren Street. Clark and Dearborn Streets were being converted to one-way traffic, which necessitated some track work.

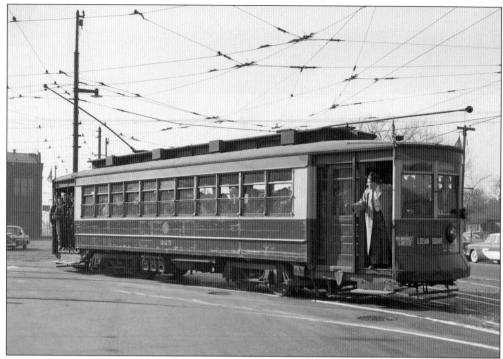

CTA Red Pullman 225 is shown here on a mid-1950s fantrip at the Seventy-Seventh Street Shops. The big man at front is Maurice Klebolt (1930–1988), who organized many such trips for the Illini Railroad Club. He later moved to San Francisco and helped start the historic Trolley Festival there, now the Muni E and F heritage streetcar lines. Car 225 is preserved at the Seashore Trolley Museum in Maine. (Chuck Wlodarczyk photograph, author's collection.)

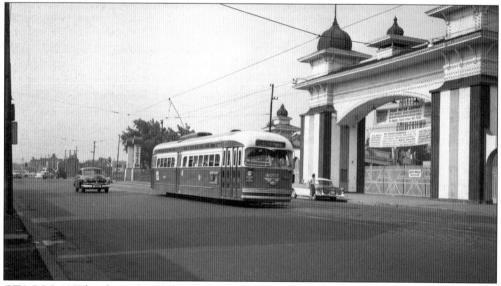

CTA PCC 4057 heads north on Western Avenue near Riverview Amusement Park at Roscoe Street in June 1956, just prior to the end of streetcar service on Route 49. Riverview is fondly remembered by Chicagoans of a certain age as a place where you could "laugh your troubles away." It closed without warning following the 1967 season. (Robert Selle photograph, Wien-Criss Archive.)

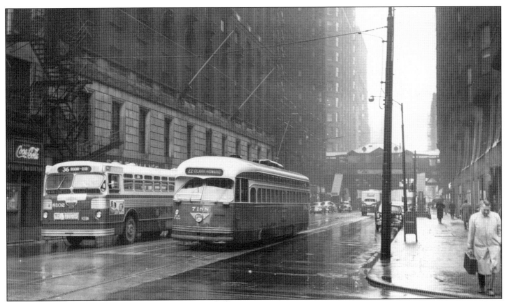

CTA PCC 7188, heading north on Dearborn Street at Jackson Boulevard in April 1957, passes Flxible propane bus 8102. These buses were severely underpowered and had great difficulty maintaining schedules. The CTA's preference for propane buses was short-lived, and no more were purchased after 1963. Propane explosions at the North Park, Kedzie Avenue, and Sixty-Ninth Street garages may have contributed to this decision. (Richard S. Short photograph, author's collection.)

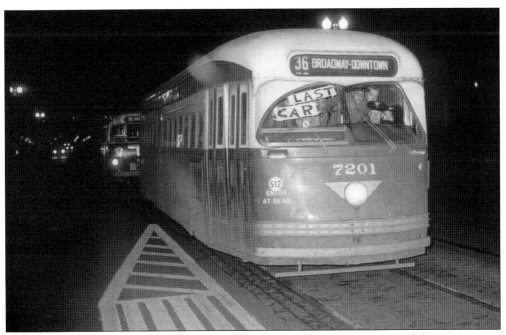

PCC 7201 became the last Route 36–Broadway streetcar in the wee hours of the morning on February 16, 1957. It is shown here at Clark Street and Devon Avenue. (Charles H. Thorpe photograph, Wien-Criss Archive.)

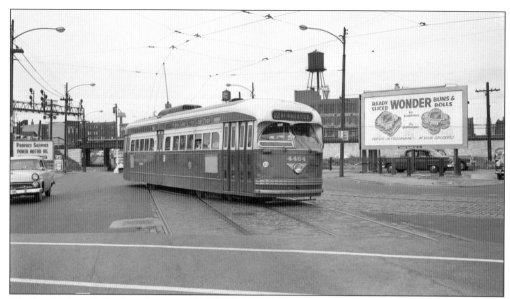

The late Robert Selle shot this picture of PCC 4406 turning from Archer Avenue onto Wentworth Avenue on the final full day of streetcar service in Chicago (June 20, 1958). The last Chicago streetcar ran in the early hours of June 21.

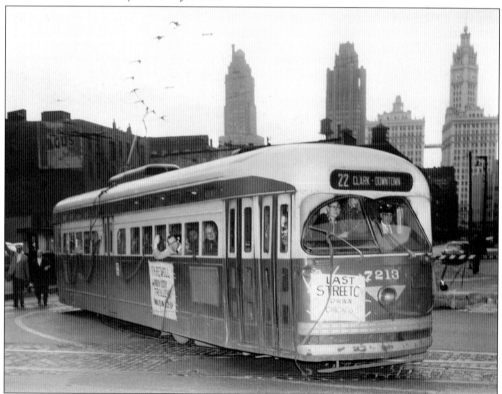

This iconic picture shows CTA 7213, the last-ever Chicago streetcar, leaving the northern terminal at Clark and Kinzie Streets in the early morning hours of June 21, 1958. (Chicago Transit Authority photograph, author's collection.)

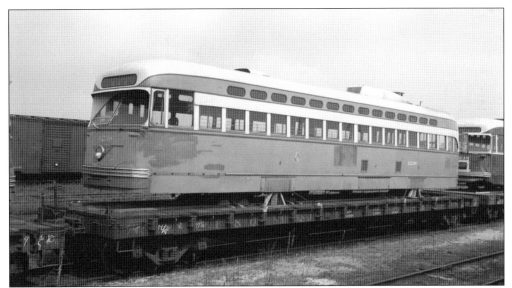

In this photograph, CTA 4238 has been retired after a very short service life and is being shipped off to the St. Louis Car Company, where parts will be removed for recycling into new rapid transit cars. The main goal of the PCC Conversion Program seems to have been getting the relatively new PCCs off the books far in advance of their estimated 20-year depreciation life. Meanwhile, cars very much like these continue to operate in a handful of American cities 65 years after they were built.

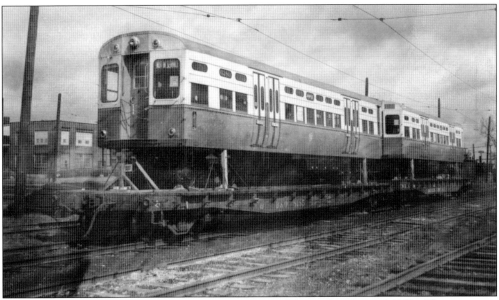

CTA "married pair" rapid transit cars 6279–6280 were delivered in the mid-1950s. These curved-door 6000s included some reconditioned parts from scrapped Chicago PCC streetcars. As the program continued, the cost of reconditioning used streetcar parts rose, to the point where the CTA admitted there was no monetary savings over scrap value by 1958, when the last such order was placed. By then, CTA's attention had moved on to the development of high-speed rapid transit cars for use in expressway medians.

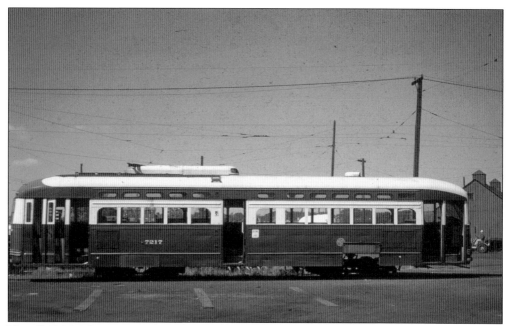

Not all 600 PCCs were sent to St. Louis for scrapping. The last two dozen or so cars left on CTA property were simply sold to scrappers. Here, car 7217 has been stripped just prior to being junked at South Shops on September 10, 1959. (Clark Frazier photograph, author's collection.)

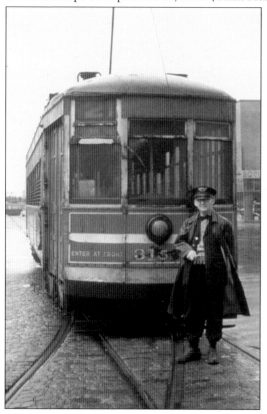

Pictured here are one-man CTA streetcar 3150 and its operator at the east end of Route 21 on Cermak Road and Prairie Avenue in June 1951. When the last of the old red streetcars were taken out of regular service on May 30, 1954, it was the end of an era, just as it was four years later, when the Green Hornets ran their last. Many of the older operators, preferring streetcars to buses, chose to retire rather than drive a bus. Unfortunately, in the many decades since, most of the people who rode as well as operated Chicago streetcars have passed from the scene. But the "end of the line" has since turned into a new beginning, for a streetcar renaissance is well underway in America. Don't hold your breath, but there may yet be a trolley in Chicago's future. After all, new streetcar tracks are going in as this is being written, just 90 miles north in Milwaukee, Wisconsin.

Nine

TROLLEY BUSES

The CSL started its first trolley bus lines in 1930 as a way of both competing with the Chicago Motor Coach Company and expanding its reach into the nascent northwest side of the city. Within a few short years, CSL had the largest such fleet in the country, while still hoping to eventually convert some lines to streetcar. This did not come to pass. The illustration is from a 1935 Surface Lines brochure. The Surface Lines served all Chicago, which the Chicago Rapid Transit Company did not.

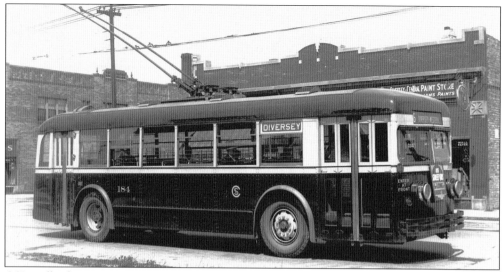

CSL trolley bus 184, a 1936 St. Louis Car Company product, ran until 1957. Interestingly, a sign on the front urges people to ride streetcars for short and long trips. (CSL photograph, Krambles-Peterson Archive.)

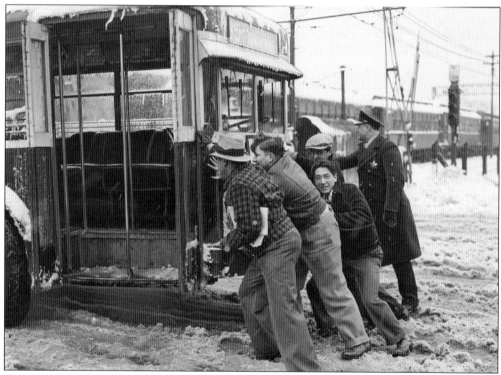

On April 7, 1938, passengers, bystanders, and a policeman are pushing a Chicago trolley bus so it can get traction on a slippery street after the city suffered a record April snowfall of more than seven inches of wet snow that crippled traffic. This picture was taken on Central Avenue, where CSL Route 85 crossed the CRT's Lake Street "L" at ground level. As far as the author knows, this was the only place in Chicago where a trolley bus crossed a trolley "L". (Acme Press photograph, author's collection.)

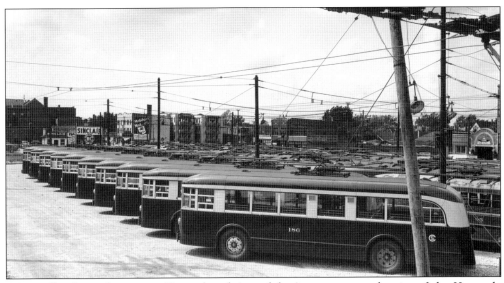

CSL trolley buses line up at Central and Avondale Avenues, now the site of the Kennedy Expressway. Some of these buses were purchased in 1937 from J.G. Brill. Trolley buses were used by CSL on the northwest side extensively. Once the CTA took over on October 1, 1947, they were also used in other parts of the city. They could not operate into the Loop, however, as the city did not want to add more overhead wires. This was somewhat reminiscent of how Chicago had banned streetcar wire from the Loop until 1906. There were fears that trolley wires might start another Great Chicago Fire.

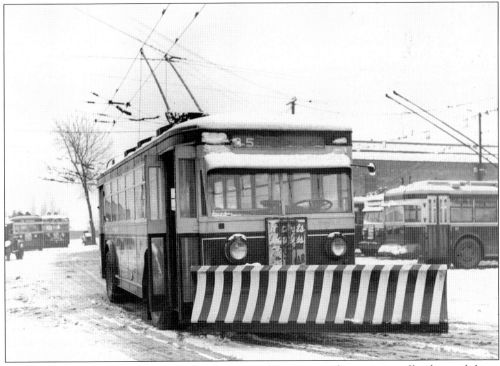

A 1931 CSL trolley bus is equipped with a snowplow. In actual practice, trolley buses did not make good snowplows. (CSL photograph, Krambles-Peterson Archive.)

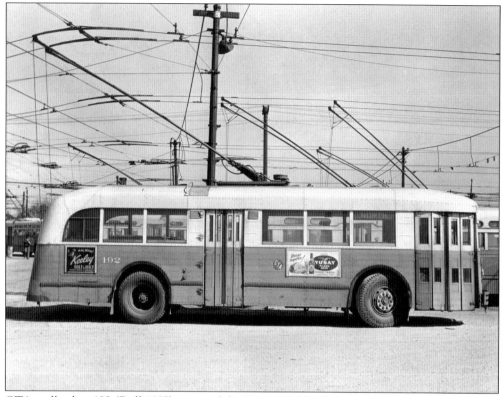

CTA trolley bus 192 (Brill 1937) is signed for Route 72–North Avenue. This bus is now at the Illinois Railway Museum. (Chicago Transit Authority photograph, author's collection.)

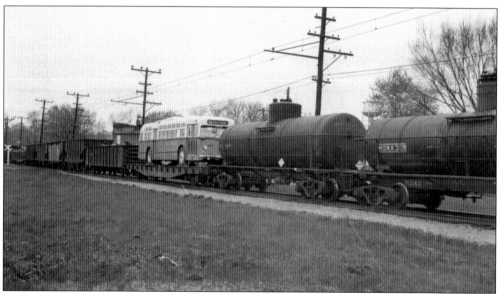

New St. Louis Car Company trolley bus 411 is on a flatcar on an Illinois Terminal freight train in April 1948. Note the catenary wire. In part, trolley freight helped transport this trolley bus. (Railway Negative Exchange photograph, author's collection.)

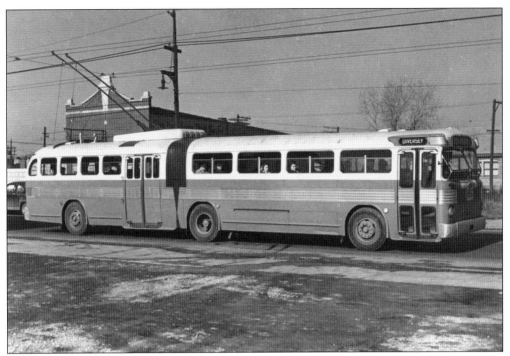

CTA 9763, dubbed the "Queen Mary" by fans, was an experimental articulated bus that was converted to a trolley coach. Retired in 1963, it is now preserved at the Illinois Railway Museum. (Krambles-Peterson Archive.)

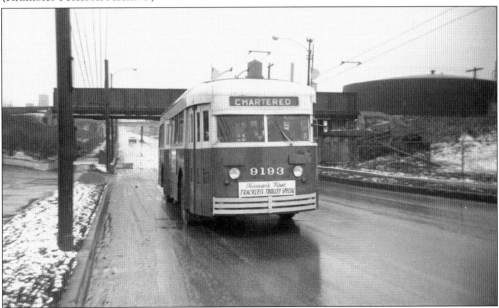

CTA 919, "Chicago's First Trackless Trolley Special," is pictured on March 2, 1958. The occasion was the very first Omnibus Society of America fantrip, which used a prewar trolley bus on South Side areas where they had not been used in service. The bus is on Kedzie Avenue, just north of the Sanitary & Ship Canal at about Thirty-Third Street. Car 9193 has been preserved at the Illinois Railway Museum under its original number, 193.

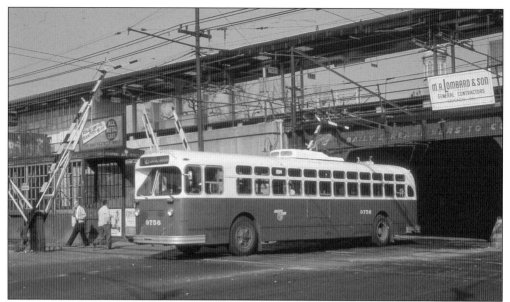

CTA trolley bus 9756 is on Central Avenue in October 1962. This is a Marmon-Herrington, built in 1951–1952. Keeping trolley bus wire and "L" overhead apart was somewhat complicated. Shortly after this picture was taken, Lake Street trains were relocated to the nearby embankment, which eliminated this problem. This is the same location as the 1938 photograph on page 114, where people are pushing a trolley bus stuck in the snow. (Charles L. Tauscher photograph, Wien-Criss Archive.)

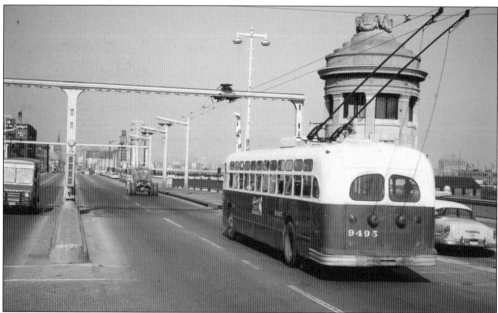

CTA 9495 is westbound on Roosevelt Road, crossing over the South Branch of the Chicago River in 1961. The trolley bus was originally numbered 495; the CTA added a "9" to all its trolley buses to differentiate them from other buses in its fleet. Marmon-Herrington buses such as these ran for 22 years in Chicago, after which many found a new home in Guadalajara, Mexico, where they ran for another two decades.

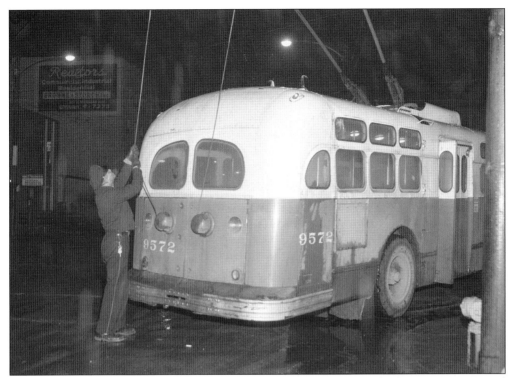

On January 23, 1965, the operator of CTA Marmon trolley bus 9572 had to get out at Grand Avenue and State Street and put the poles back on the wires. This was an occasional occurrence that CTA riders of a certain age will probably remember, along with the "singing" of the wire.

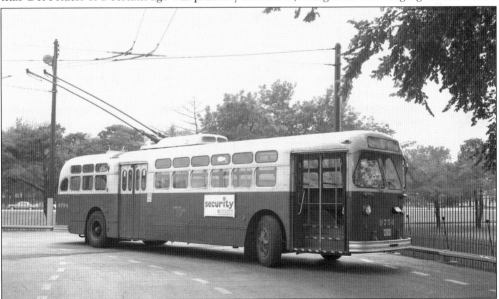

CTA Route 80 trolley bus 9754 is pictured at Irving Park Road and Neenah Avenue in the mid-1960s. This was a Marmon-Herrington, built around 1951–1952. In the postwar era, the CTA built many such off-street turnaround loops. This one is no longer in service and has been turned into a driveway for a nearby housing development.

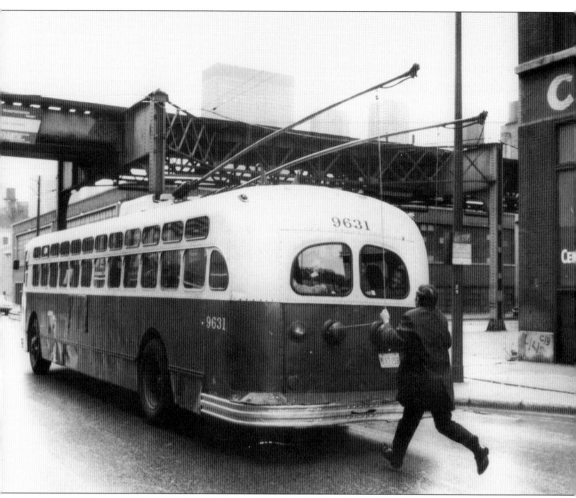

CTA Marmon-Herrington 9631 had its poles lowered for the very last time at Grand Avenue and Franklin Street by the late Glenn Anderson on April 1, 1973, after completing a fantrip that bus 9553 also took part in. This was one week after the end of 43 years of regular trolley bus service in Chicago. Both buses are preserved at the Illinois Railway Museum, which does have an operating trolley bus line. After the poles were taken down, 9631 had to be towed from here, as it could no longer run under its own power. (Chicago Transit Authority photograph, author's collection.)

Ten

PRESERVING HISTORY

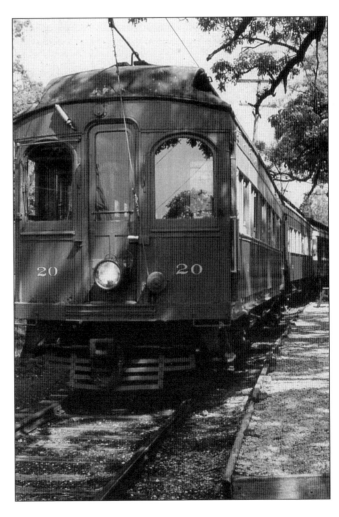

Chicago, Aurora & Elgin 20, built in 1902, had a long service life, operating until 1957. Even so, it has been retired longer than it was in service. Here it is pictured at the Fox River Trolley Museum in 1983. (David Sadowski photograph.)

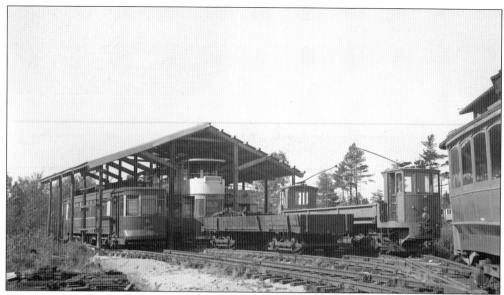

CSL/CTA "Big" Pullman 225 rests under a makeshift cover at Seashore in Kennebunkport, Maine, in the late 1950s. (Walter Broschart photograph, author's collection.)

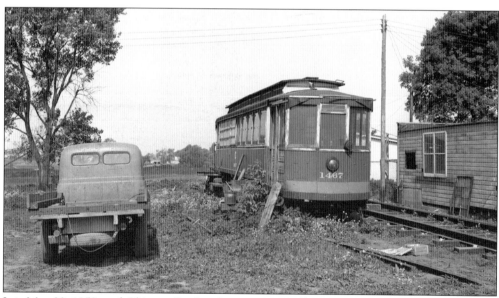

It is May 30, 1958, and Chicago Surface Lines car 1467 (former CTA salt car AA72) is at the Electric Railway Historical Society (ERHS) site on Plainfield Road in Downers Grove. This "Bowling Alley" car was built by the Chicago Union Traction Company in 1900. It went to the Illinois Railway Museum in 1973. (Robert Selle photograph, author's collection.)

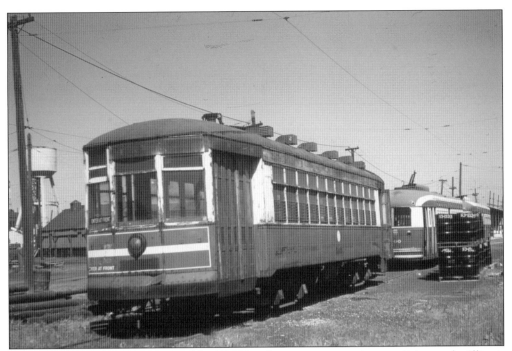

This is CTA 3142, which was saved by ERHS and is now in operating condition at the Illinois Railway Museum. In this photograph dated September 10, 1959, there are still a few PCCs left on the property at South Shops, including car 4400. Car 3142 was built by Brill in December 1922 and was known as a "169" or "Broadway-State" car. It was converted to one-man operation in 1949 and retired in 1954. (Clark Frazier photograph, author's collection.)

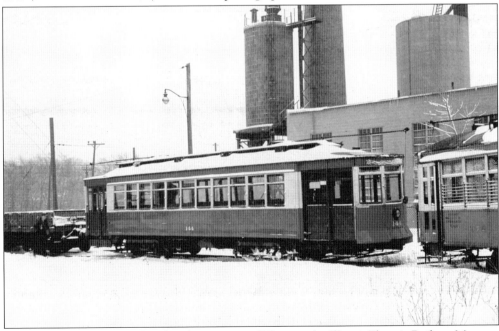

CTA Red Pullman 144 and Milwaukee streetcar 972 are at the Illinois Electric Railway Museum in North Chicago in February 1960. The museum moved to Union in 1964.

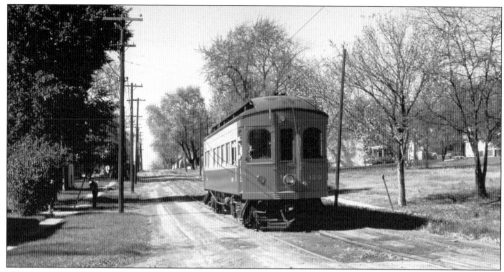

Chicago, Aurora & Elgin car 320 was the last piece of equipment moved off the property in 1962, following abandonment. It was also the first CA&E car to run again, on the Southern Iowa Railway. Here, the 320 is on Madison Street in Centerville on October 20, 1962. It was built in 1914 by Jewett Car Co., and is now at the Midwest Electric Railway in Mount Pleasant, Iowa. (James D. Johnson photograph, author's collection.)

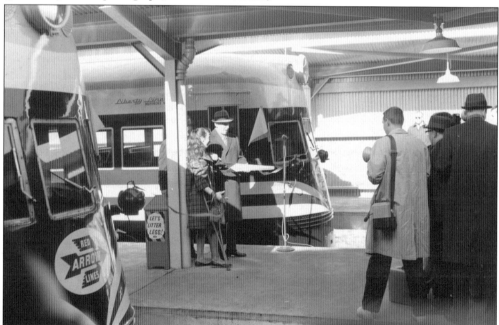

On January 26, 1964, just a year after North Shore Line service ended, Merritt H. Taylor Jr., president of the Philadelphia Suburban Transportation Company (also known as the "Red Arrow Lines") introduces the two former Electroliners, now rebranded as "Liberty Liners." They continued to run on the 13.4-mile Norristown High Speed Line until about 1976. One set (801–802) is now at the Illinois Railway Museum (IRM), while the other (803–804) is at the Rockhill Trolley Museum in Pennsylvania. The IRM Electroliner is undergoing a complete restoration. (David H. Cope photograph, author's collection.)

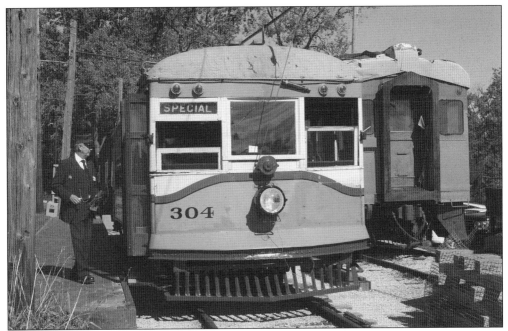

Aurora, Elgin & Fox River Electric 304 prepares to depart at the Fox River Trolley Museum in September 2013. It is extremely gratifying that this car came back after an absence of nearly 75 years to once again run on its home rails. It is a wonderful example of 1920s technology. (David Sadowski photograph.)

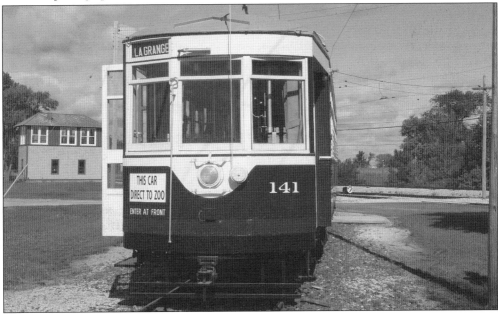

Chicago & West Towns 141 is now restored to operating condition at the Illinois Railway Museum. When the car was saved in the late 1950s, there was nothing left except the body. Each missing part had to be replaced with an authentic one, a restoration project that took over 20 years. Parts came from as far away as Egypt. Restoring this car was a labor of love for project manager Frank Sirinek. (David Sadowski photograph.)

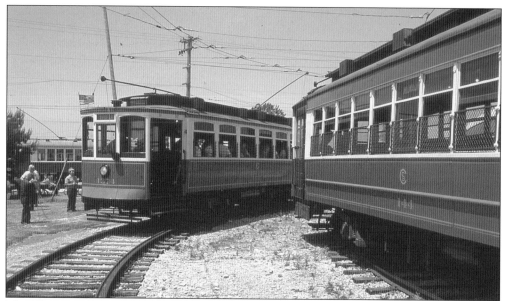

The Illinois Railway Museum has the largest collection of Chicago streetcars in the world. Here are cars 1374 and 144 in the late 1980s, shortly after the former, known as a "Matchbox," was restored. (David Sadowski photograph.)

CSL/CTA 225 was photographed at the Seashore Trolley Museum in August 2014. This is the oldest such museum in America, and over the years, carbarns such as this one have been built to protect as much of the collection as possible from the elements. This car is occasionally operated and is still largely in original condition. (David Sadowski photograph.)

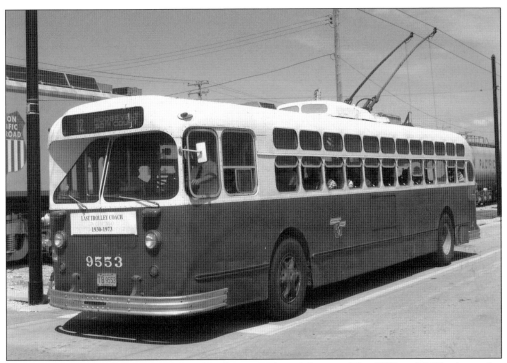

CTA trolley bus 9553 now operates at the Illinois Railway Museum. The 9553 and 9631, also at the museum, were the two last Chicago trolley buses to run in 1973. (David Sadowski photograph.)

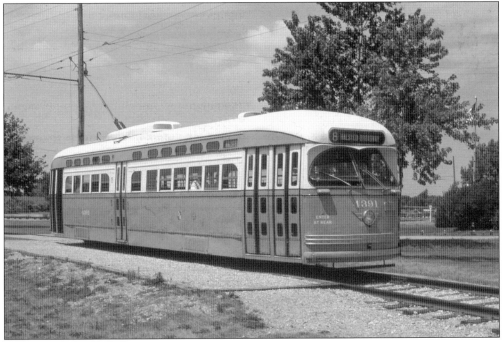

CTA 4391, the only operable Chicago PCC streetcar, lives on at the Illinois Railway Museum. It is worth a trip to Union, Illinois, just to ride this car, as Chicagoans once did, at a "museum in motion." (David Sadowski photograph.)

DISCOVER THOUSANDS OF LOCAL HISTORY BOOKS
FEATURING MILLIONS OF VINTAGE IMAGES

Arcadia Publishing, the leading local history publisher in the United States, is committed to making history accessible and meaningful through publishing books that celebrate and preserve the heritage of America's people and places.

Find more books like this at
www.arcadiapublishing.com

Search for your hometown history, your old stomping grounds, and even your favorite sports team.